A3033

Cover illustration:
Michael Rothenstein
Love machine 1971
Catalogue number 153

© Arts Council of Great Britain, 1978
© Text: Pat Gilmour
Exhibition organiser : Karen Amiel
Exhibition assistant: Alison Brilliant
Catalogue designers: John Mitchell and Crispin Rose-Innes
Design assistant: Julia Binfield
Printers: CTD Limited, Twickenham, England

ISBN: 07287 0156 1

THE MECHANISED IMAGE

——— AN HISTORICAL PERSPECTIVE ON 20TH CENTURY PRINTS ———

Arts Council
OF GREAT BRITAIN

CONTENTS

55 **Karl Schmidt-Rottluff** (b.1884)
Mädchen aus Kowno 1918
Woodcut
50 × 38.7cm

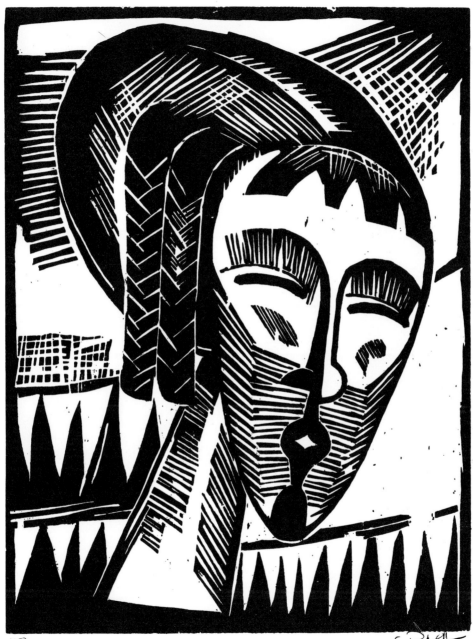

117 S. Rottluff

FOREWORD

We had discussed the possibility of organising
an exhibition of print methods for a number of
years and it wasn't until we began discussions
in 1974, with Pat Gilmour then Assistant Keeper
in the modern collection at the Tate Gallery,
that we extended our original notion of a
touring exhibition on a modest scale to an
altogether more ambitious project, the intention
of which was to go much further than a mere
explanation of the various printmaking
techniques. It seemed to us and to Pat Gilmour
that there was a large public who found it
difficult if not impossible to distinguish one
technique from another or indeed the difference
between an artist's print and a reproduction.
And what of the confusing situation with artists'
signatures and edition numbers! We were
delighted when Mrs. Gilmour agreed to select
and write the catalogue for a didactic exhibition
tracing the development of printmaking
techniques historically and up to the present in
order to demonstrate the enormous expansion
and versatility of graphic techniques, and the
qualities that can take an image beyond
reproduction or multiplied drawing. The prints
in the exhibition are chosen for their high
artistic and technical quality, but, in order to
give a fuller technical exposition, we have also
commissioned a slide presentation.

 We are indebted to the many artists and
public and private lenders who have so kindly
agreed to lend to our exhibition. We would like
to single out for special mention the extremely
generous scale of loans of 19th and 20th century
prints from the Victoria and Albert Museum —
drawing on the collections of the former
Regional Services Department, and of the
Library and Prints and Drawings Departments —
and from Cartwright Hall, Bradford,

15 **Anthony Gross**
Threshing 1956
Etching
(detail)

Joanna Drew
Director of Exhibitions
Karen Amiel
Curator of the Arts Council Collection

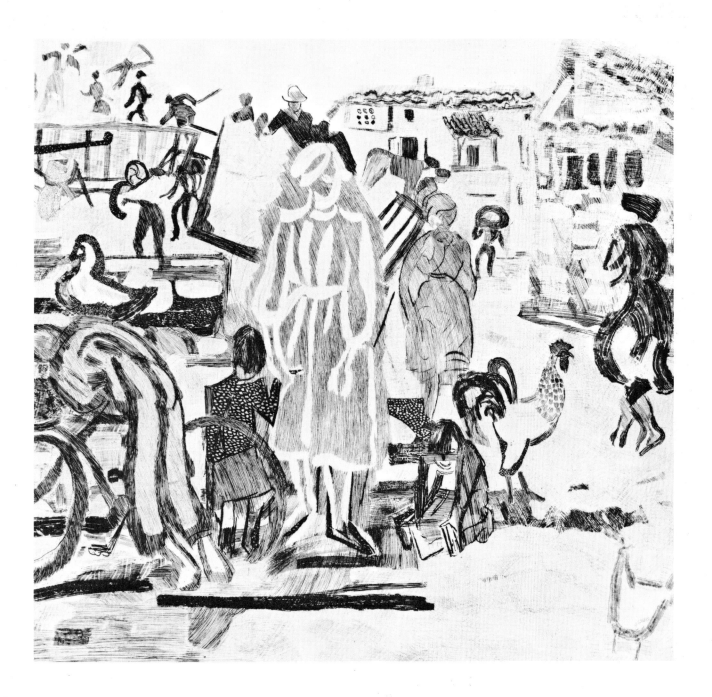

INTRODUCTION

Making a print is essentially a way of mechanising an image, but because we have retained, against the odds, what Walter Benjamin called a 'fetishistic fundamentally anti-technological notion of art', the story of artists' prints, particularly during the last hundred years, reflects a fascinating ideological struggle. On the one hand there has been the technological production with its so-called 'impersonal' qualities — the regularity and precision of conscious design and division of labour in the making — and that climax and apotheosis of the individually hand-crafted, the allegedly more human 'original' print.

During this period, the photograph, itself an editionable print, was a form of image-making around which a great many of the hand/machine controversies raged. For with its causal relationship to the distribution of light in the actual world and its early sales motto: 'You press the button and let Kodak do the rest', photography always appeared to produce the most automatic of images and was therefore scarcely allowable within the canon of art. After continual reassessment we now realise that as it converts a three-dimensional experience into a two-dimensional subliminal graduation of darkened salts in paper, its idiosyncratic monocular vision and planar focus, not to mention the subjective variables an artist may wield in the course of its making, render it rather more than the pure communication in a miraculous one-to-one relationship with events and objects in nature that once we took it for. Certainly in its myriad applications, from half-tone to video, information is converted into codes in their own way as arbitrary as those of the old manual reproductive engravers it replaced, who probably told us as much about themselves and the medium they were using, as they did about whatever else they were trying to convey.

We now appreciate that there is a deal of truth in the saying: 'Photography is the photographer'. For where the operator is powerful enough, even so-called 'mechanical' images have an uncanny way of being stamped by the personality of their creators. Somewhat to our surprise, even screenprinting, reviled in some circles as the most anonymous of print techniques, equally betrays its origin. No matter how coolly geometric, a Vasarely is unlikely to be mistaken for a Reinhardt, or a Riley confused with an Albers. Indeed, the latter has explored with his uncompromisingly rational and absolute constructions of squares within squares, the subjectively variable, even meditative, effects of colour.

While the histories of artists' prints of the last century have rarely mentioned photography or the equally taboo photomechanical adaptations of the four main graphic processes, the last two decades have seen these pariahs not only entering art as a central means of communication, but, since technological and autographic stances can be wonderfully confused, even borrowing such restrictive conventions as limitation of edition, until the ultimate absurdity, the unique photograph, has become one of the more bizarre phenomena of the capitalist market-place.

172 **Graham Sutherland** (b.1903)
Predatory form 1953
Lithograph
75.5 × 56cm

8

Before photography made its alarming take-over of many of art's functions and machinery constituted a promise rather than a threat, precision finish in a print was not abhorred, but revered. Van Dyck and Hogarth, to name only two historical artist-engravers, both conformed to the contemporary taste as to what was proper and complete, rather than following their own somewhat sketchier aesthetic inclinations, that we much prefer today. In the case of the 18th century *estampe galante*, the production of which was divided between draughtsman, etcher, engraver, border decorator, and letterer, the Academie Royale forbade the sale of its earlier states in case lack of finish damaged the artist's reputation.

Those who have decried the technical division of labour, indeed stupid in the case of 19th century composite wood-engraved pictures for such papers as the *Illustrated London News*, have rarely taken into account that it also brought into being some of the most beautiful colour prints in the world. Of seminal importance in their influence on the modern movement, these were part of the Japanese Ukiyo-e reproductive woodblock tradition in which, despite fragmentation of production, an exquisite result emerged from the collaboration between artist, craftsman-cutter and the printers who hand-rubbed unlimited editions of the inexpensive sheets. For the idea that humble images inevitably mean mediocrity while artists' 'original' limited edition prints unfailingly mean excellence, can be a misleading equation.

A rejection of the systematic dots and furrows of reproductive engraving which had dominated several centuries and the deification of autographic hand-work embodied in the concept of 'originality' became of increasing importance in the 1880s as photography grew more and more mechanised. An 1888 French portfolio, precursor to *L'Estampe Originale* defined 'originality' for France. In England, the amateur English etcher, Sir Francis Seymour Haden elevated original prints in contradistinction to what was then the reproductive norm at the Royal Academy. Whistler, active both sides of the Channel, was the epitome of the emergent individualist *peintre-graveur*. Under the 'art for art's sake' banner, he boosted uniqueness by such devices as manipulating surface ink on his etching plates so as to confound 'mechanical' ideas of regularity and identicality. He made watchwords of spontaneity and intuition. Perhaps even more important in its implication for future practice, he adopted the limited edition, selling signed and numbered prints at double the cost of unsigned examples of identical pictures and emphasising snobbish connoisseurship and mystique at the expense of content, by suggesting his signature was as valuable as whatever the image had to say.

Several 19th century artists and critics disapproved of this artificial limitation. PG Hamerton asked, in relation to the steel-facing that made longer print runs from metal plates possible, whether it would be a bad thing if there were a million perfect copies of Rembrandt's finest works. 'Are there not a million copies

137 **James Rosenquist** (b.1933)
Spaghetti 1970
Lithograph
(detail)

of *Hamlet*, and do we value Shakespeare less?' he queried. He also summed up the situation in England in the second half of the 19th century when, writing with a note of pathos about the Royal Academy, where most of the available space for prints was given to reproductive engraving, he commented on the official notice 'ENGRAVINGS' printed in capitals, while the words 'and etchings' had only been added by an enthusiast's pencil graffito.

'How curiously this typifies the condition of the two arts' he remarked. 'ENGRAVINGS' in big black capitals, rigid, official, formal, mechanical, impersonal, mindless . . . and etchings written with a pencil in free autography every rapid sweep and curve of the point an indication of temperament and will.'

The Tachist and Abstract Expressionist manifestations of the 1950s represented the apogee of this emphasis on manual gesture. In printed art, any graphic strategy conveying the illusion of white-hot inspiration and freedom was in the ascendant — lithographic splash and splatter, etched graffiti, or the sugar-aquatinted sweep of the brush.

In that era, one might have supposed careful calculation and regularity did not also stem from man, had not the opposite polarity already expressed itself in the work of the Constructivist artist/ engineer of the 1920s. Moholy-Nagy, for example, wishing to side-step vanity and serve the public anonymously, asked an enamel factory to manufacture a set of paintings for him as early as 1922.

In a later account of his activity, Moholy wrote: 'An airbrush and spray gun can produce a smooth and impersonal surface treatment which is beyond the skill of the hand. I was not afraid to employ such tools in order to achieve machine-like perfection. I was not at all afraid of losing the 'personal touch' . . . I could not find any argument against the wide distribution of works of art, even if turned out by mass-production. The collector's naive desire for the unique can hardly be justified. It hampers the cultural potential of mass consumption . . . In an industrial age, the distinction between art and non-art between manual craftsmanship and mechanical technology is no longer an absolute one . . .'

The oscillation between the hand-crafted and the 'machine made' was re-enacted in the story of screenprinting — a graphic technique entirely of the 20th century. First taken up by the Americans in the late 1930s, in a manual gestural form dubbed serigraphy to emphasise that fact, it was only later, when artists put it into the hands of master-printers, that its photo-mechanical and precision stencil applications served the post-painterly abstractionists. The medium, together with offset lithography, also became of major concern to Pop artists, the content of whose work was quite often based on commercial print process — Lichtenstein's borrowings from the strip cartoon or Rosenquist's love affair with the billboard, for example.

Warhol, screenprinting on canvas or composing in serial repetitions, brought the realisation that an image of one of his works in the catalogue was not so much a reproduction, as a variant. Similarly, Gerd Winner's stunning photo-screenprints on

219 **Gerd Winner** (b. 1936)
Bankside 1973
Screenprint on canvas
189..5 × 234.5cm

canvas also raised the question of scale and status in printmaking's bid for autonomy as a primary medium.

As they, together with many other artists, blurred the distinction between original and reproduction, one was reminded of the way the Dadaists had already hastened the bourgeoisie into apoplexy, springing leaks in watertight definitions by such devices as frottage which allowed prints to be hand-drawn or drawings to be printed and integrating printed 'ready-mades' into their work, as Pop artists were increasingly to do. Throughout the 1960s the infinitely subtle Richard Hamilton, infusing print with hand-work and painting with print in his analysis of mass-cultural forms, highlighted the fact that the most photomechanical reprographic techniques rely a good deal on hand touching, while the most autographic of prints employ considerable mechanics. His hand/machine synthesis was 'not a threat to the human condition, so much as a means of achieving a renewed integration of life and art'.

Process can therefore be seen at the very heart of meaning and print has proved, particularly if one considers its appearances over the last decade in the domain of artists' photographic and typographic documentation, a particularly flexible and encompassing arena for a complex spectrum of aesthetic ideas.

The writer who mentions technique is apt to be rapped over the knuckles. William Ivins, one of the great print enthusiasts and historians, refreshing in his debunking of the hierarchical value-judgements engendered by editioned art, was in many ways right to note disapprovingly that when a man asked whether you thought something was a good etching, he referred to the technique rather than the idea . . . 'an inversion of intent and importances that has fooled a great many innocent people'.*
On the other hand, technique and content are also inseparable, and one may agree equally with JP Sartre that technique itself frequently implies or embodies a philosophy.

The tiniest detail — an etching mordant chosen for slow deliberation and finesse rather than raw speediness — can betray an artist's feeling as much as a major decision about the editioning itself, in which endlessly nuanced and therefore expensive variants are destined for an elite, or mass production procedures democratise art's distribution through cheap availability.

Dubuffet, animating apparently banal and inert materials such as dust, grass and market refuse and inking and imprinting them in order for them to reveal themselves, wrote of his method as 'a machine for checking all reason and replacing everything in ambiguity and confusion'.

'Is it not the blood of metaphysics which irrigates this whole work in ink down to its least important technical processes?' he asked. 'And besides, imagine an artistic undertaking — or what is expected of art these days — which would not raise the metaphysical view of the operator from their very foundations. What would a work of art be worth in which each of the smallest parts — the least strokes — did not describe in one sweep, its author's entire philosophy?'

240 **John Hilliard** (b.1945)
765 paper balls 1970
Photograph
122 x 122cm

14

* William Ivins — *Prints and Visual Communication* — MIT Press 1953

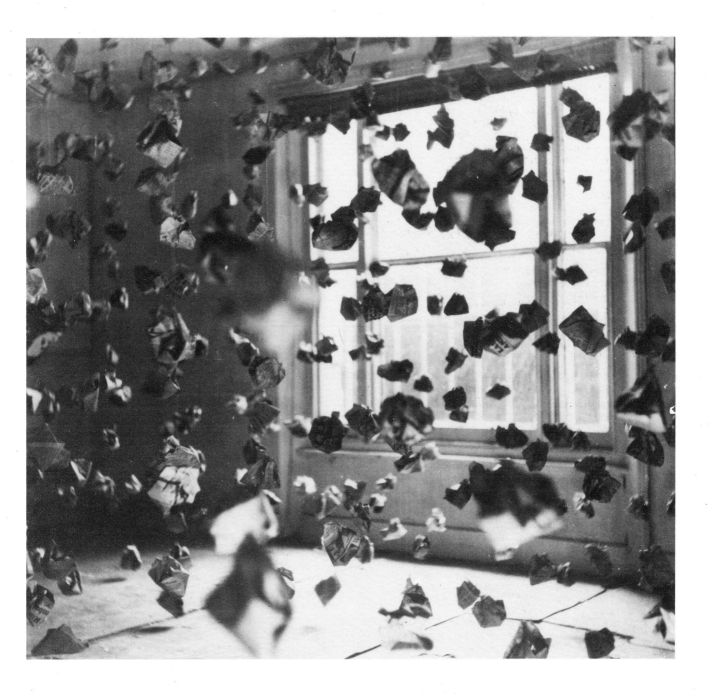

PRINT CONCEPTS

A definition

William Ivins defined a print as an exactly repeatable
pictorial statement. It involves the transfer of an image
from one surface to another by means of a duplicating
tool or set of tools — relief blocks, intaglio plates,
lithographic stones, or screens. To make a simple
printed line by each of these four main graphic
techniques, the artist must prepare as an ink carrier a
ridge standing proud in a wood or lino block; an incision
cut or corroded in metal; a greasemark deposited on
a porous stone; or an open chink in a shallow
framework of otherwise impervious tautened gauze.

Perhaps the most familiar print is one's footprint in
sand, or a dirty fingerprint upon a wall — the first an
inkless embossing, the other a relief print in which the
ridges carry colour. Prints involving photographic
images are far more complex. Since the photograph
was, in its early days, fugitive, on ugly paper and
incompatible with type because realised by quite
different operations from those producing text, it was
usually mechanically translated into one of the other
print media — a technical possibility since the 1880s.

To render the continuous tone of a photograph in a
single black inking, the original has to be broken down,
converting its greys into a dot structure by filtering them
through a finely ruled grid on glass so that the pale
areas become scattered drifts of tiny dots, while in the
dark ones, the dots assume larger proportions, even
running into one another. This procedure is called
half-tone process; for printing on fine paper the dots
may be subliminal, on coarse paper, like newsprint,
they are obvious even to the naked eye.

In *A definition of a print* (1), the portrait of Norman
Thompson, complete with roller and ink, the attributes of
a printer, has been rendered into a half-tone metal
plate, then printed in an etching press. The overlaid
impression of the artist's downward-bearing hand,
which would have been difficult to position and edition
exactly by repeatedly inking the actual flesh, has been
made into a sophisticated stencil and screenprinted onto
transparent acetate.

The artist has thus used not only the simplest, but
also the most complicated of techniques, to set up a
classic tension between the hand-done and the
mechanical. The image is characteristic of the autonomy
print has achieved in the 20th century, for the idea, a
subtle analysis of printed art itself, could not have been
communicated without it.

1 **Norman Thompson** (b.1951)
A definition of a print 1974
Photo-etching and screenprint
48.5 × 47.5cm

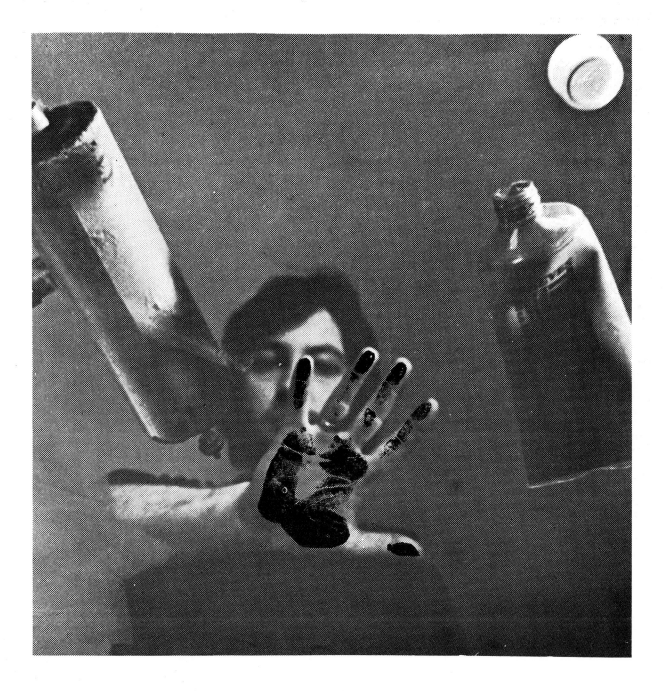

The ubiquity of print

Before photography, however, prints had to fulfill all the functions of repeatable image-making and one of their major jobs was to popularise the work of artists in other media. Although it sometimes did happen that an artist would make an 'original' print himself, it was rather more likely that he would use a reproductive craftsman. Raphael was first to organise himself in this way, using Marcantonio Raimondi as the engraver of his drawings some of which were specifically for graphic reproduction. Latterday critics of the highly rational linear style Marcantonio devised to convey Raphael's essence, which became the basis for reproductive engraving all over Europe, castigate it for being a standardised form of mass-production, the sole idea of which was the commercial possibility of large editions. While the whole point of making an engraving at this date was to be able to circulate it as widely as possible, it seems likely that Marcantonio's style was formed at least as much by the attempt to relay the volumetric qualities of Raphael's draughtsmanship and the High Renaissance ethos. This Hauser* characterises as an artistic formalism corresponding to the moral conception of decorum held by the upper classes of the period. 'For this society, self control, the suppression of the passions,the subduing of spontaneity . . . are the highest commandment . . . The rules of discipline and order in the conduct of daily life find their closest analogy in the principles of economy and conciseness which art imposes upon itself . . . the restriction of representation to the bare essentials.'

Elements from *The Judgement of Paris* **(2)**, by Marcantonio after a lost Raphael drawing, have resounded countless times through the history of art. Most memorably the group sitting on the right side of the picture shocked the world when the men, but not the ladies, adopted 19th century dress and found their way into Manet's *Déjeuner sur l'herbe*, thus demonstrating the ubiquity and long range influence of prints. Contemporary artists, Picasso among them, have continued to find stimulation in the scene Marcantonio first circulated more than four-and-a-half centuries ago.

Alain Jacquet, with his updated modern costume version, **(3)**, has abandoned line for tone and used an enormously coarsened trichromatic dot taking normal colour reproduction to the point where the picture, more about process than a picnic, becomes a series of almost abstract blobs. It has another interesting twist. The huge screenprint, in an edition of 95, has been made on two joined panels together measuring about 5½ × 6½ feet. This raises all sorts of questions as to how a print becomes a painting, for Jacquet is one of a number of artists (Andy Warhol and Gerd Winner being others) who have printed large scale works on canvas, thereby endowing them with intriguingly equivocal status.

2 **Marcantonio Raimondi** (1480-1534)
Judgement of Paris (after Raphael) 1510
Engraving
43.8 × 20.1cm

Judgement of Paris (after Raphael) 1510
(detail)

3 **Alain Jacquet** (b.1939)
Déjeuner sur l'herbe 1964
Screenprint on two panels
175 × 195cm

18

* Arnold Hauser: *The Social History of Art* (Book II) Routledge, Kegan and Paul.

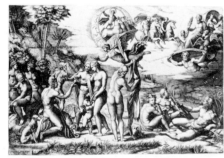

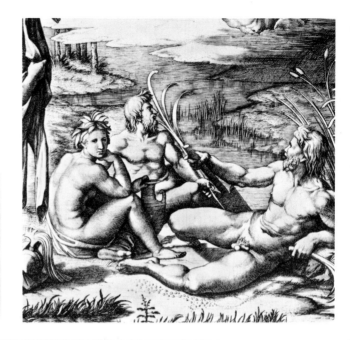

Reproductions

The majority of historical reproductions have not been exact facsimiles, which even now are difficult, sometimes impossible to make, but interpretations dependent upon a second man's sensibility in manually transposing an image into another medium.

When the Crown was petitioned in the early 19th century to allow engravers full membership of the Royal Academy, the petitioners were refused on the grounds that engraving was wholly devoid of the intellectual qualities of invention and composition. Engravers had copied for so long, that it simply didn't occur to the General Assembly that they might originate work on the plate, despite the evidence Rembrandt offered to the contrary. When in mid-century Victoria was successfully approached, engraving was likened to translation and Dryden was offered as authority that . . . 'to be a thorough translator, one must be a thorough poet'.

The 20th century swing to 'original' composition, as if reproduction were immoral, has obscured the fact that such craftsmen could indeed be poets, as can be seen from two 19th century artists who interpreted Constable. David Lucas worked in mezzotint under the supervision of the artist who asked for radical alterations as the work progressed. In this softly tonal medium (with which Turner's craftsmen deadened the pedestrian sepia plates of his *Liber Studiorum*) Lucas managed to convey all the excitement of scudding cloud and sparkling foliage **(4)**. Thoroughly different, yet equally inventive, are Timothy Cole's late 19th century efforts for *The Century Magazine* when, with the dying embers of white line wood engraving already superseded by the photographic half-tone, he made several idiosyncratic and fascinating Constable reproductions **(4.1)**.

Theoretically, photomechanics took over reproduction from this time. Yet there are plenty of 20th century examples in which an artist's work has been hand reproduced, particularly lithographically, although the craftsman is rarely any longer acknowledged. For while a photolithograph distorts a painting almost as much as a small scale black and white print does, inevitably altering its colour, size and the 'facture' of oil paint, hand copying can at least dispense with mechanical dots and the crudely simplistic trichromatic palette.

Post-war, when School Prints were encouraging artists to make original prints for children, LS Lowry, who felt he couldn't personally cope with colour autography, allowed his painting *Punch and Judy* **(5)** to be hand lithographed by an un-named craftsman and sold in an edition of 6,000 as cheaply as a photomechanical print. Subsequently another company persuaded Lowry to sign 75 from the edition's residue. Prints which days before had cost a few pounds, miraculously jumped to £100 overnight, the unsigned remainder costing £20 apiece. Photomechanical Lowrys have been similarly signed.

An artist's signature is held to confer approval — authentication. Indeed, one of the 'originality' definitions said a print couldn't be 'original' without it. But if 75 were signed, were 5,925 disapproved? And is a signature magical enough to warrant £97?

4 **David Lucas** (1802-1881)
Reproduction after Constable's
'**Spring, East Bergholt Common**' 1829/30
Mezzotint
(detail)

4.1 **Timothy Cole** (1852-1931)
Reproduction after Constable's
'**Cornfield**'
1899/1900
Wood engraving
(detail)

5 **After LS Lowry** (1887-1976)
Punch and Judy 1947
Reproductive lithograph
49.5 × 76cm

Signing and limitation

The rituals of signing and limitation, which began with reproductions controlled by the Printsellers' Association in the 19th century, were taken into the realm of the original print by Whistler, who charged twice as much for a lithograph signed in pencil (often with his ethereal butterfly) as for an unsigned proof.

Overestimated during his lifetime as the greatest etcher since Rembrandt, Whistler made a fetish of manipulating the ink on his etching plates in a way which made practically every sheet a unique monotype. Print artistry, he thought, derived from a multiplicity of impressions from one source. William Ivins, perhaps forgetting Rembrandt did the same, remarked that this was raising technical incompetence to artistic virtue. Yet behind the appeal to snobbery through rarity, there lurks the hand competing with the photograph. As Théophile Gautier remarked: 'The need to react against the positivism of the mirror-like camera has forced more than one painter to take to the etcher's needle.'

While limited numbers ensue automatically from frangible drypoints or such tender images as Whistler's lithotint (6) (the tenuous smudges and almost Chinese atmospheric perspective of which perfectly convey the silvery delicacy of river mist) most print techniques give infinitely longer runs. And although rarity undoubtedly attracts snobs, it is not the only rationale for limitation. As art historian Reyner Banham queried when multiples (inexpensive three-dimensional art objects in unlimited editions) were mooted: . . . 'a shelf of identical Pasmores in every self-service store? Last year's Paolozzis in every suburban dustbin?' Large editions not only require storage, but middlemen more highly organised for mass-distribution than the average art dealer. Artists justifiably fear that if they silt up the world with slow-selling images, they may be prevented from making fresh ones. Then, given two first-class images by the same artist, one cheaply unlimited, the other expensively rare, the public have a dangerous device with which to measure the intrinsic and extrinsic values of art.

Nevertheless, a number of artists have found, with Baskin, that limitation is 'a stupid and vicious practice unhallowed by time' . . . and that 'it is aberrant to print 50 impressions when 500 are possible'. While commissioning publishers usually insist on limitation, Baskin himself has published a series of mastodon woodcuts up to 8 feet high in unlimited editions, one such outsize print *The angel of death* (7), expressing the idea of 'ravaged man perishing in spiritual corruption'.

It is one of the sadder ironies that print's potential as a demo-cratic medium sharing artists' ideas with the world at large rather than just with rich collectors, is more than outweighed by its potential as big business. But there are critics within the system.

6 **James McNeill Whistler** (1834-1903)
Early morning, Battersea 1878/87
Lithotint
16.4 × 25.9cm

Early morning, Battersea 1878/87
(detail)

7 **Leonard Baskin** (b.1922)
Angel of death 1959
Wood engravings and block bearing
157.5 × 78.7cm

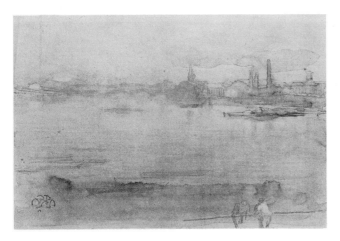

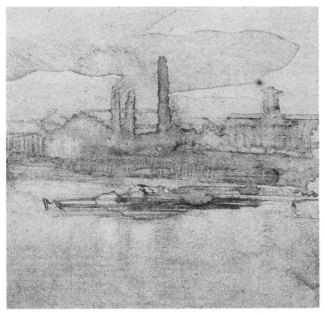

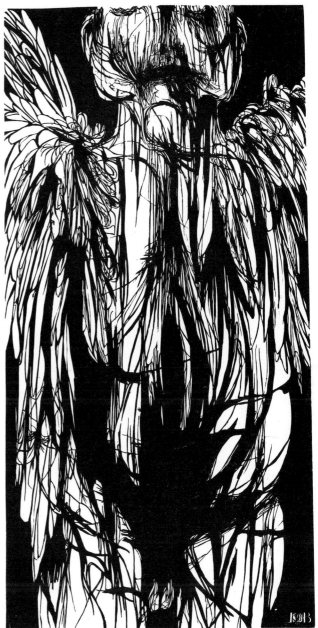

Signing and Limitation continued

Marcel Broodthaers, Belgian poet and artist who mordantly defined engraving as 'market study' summed up the situation in his two-sheet screenprint *Poème-change-exchange-wechsel* **(9)**, in which rows of his signatures (the poem) are gathered together in the bureau-de-change to be issued as deutschmarks, francs, pounds and dollars.

Les Levine, commenting equally pointedly on art as investment, dabbled in the stock exchange and in an advertisement in the magazine *Artforum* declared the 220 per cent profit that he made was his work of art. Roy Grayson, choosing an offset postcard to represent a medium most antithetic to snob values **(11)**, issued it in a signed limited edition. The techniques (as opposed to the vehicles) employed in these three post-romantic works are, to a very great extent, irrelevant; other techniques would have done. It is not 'truth to materials' but home truths that these artists explore.

20th CENTURY AUTONOMY IN PRINT

'Truth to materials'

Truth to materials has, nevertheless, been one of the most important concepts in establishing the autonomy of print during the 20th century. For it is in stressing the nature of their means, that artists have broken away from the immemorial conception of prints as imitations of works in the unique media.

Of all the modern artists who have used print for its own qualities, the contemporary Japanese are among the most extreme. Artists in the creative print movement, who completely rejected the tenets of the Ukiyo-e tradition, vary the colours, or even the form of their prints whenever they take a fresh impression. Indeed, Saito, Kiyoshi, whose print won the Sao Paulo Biennale in 1951 against all-comers, once did not realise that prints were editionable.* His primary motive was the quality he could achieve with his chosen materials.

Variations on a theme by Murai, Maçanari, **(22)**, shows the extent to which the medium conditions the message. The lithograph blooms sweetly and effortlessly on the paper; the woodcut, with its much denser blackness, becomes one with the sheet, revealing in the unmistakable traces of knife and gouge, the artist's battle with intractable materials.

9 **Marcel Broodthaers**
Poème-change-exchange-weschel 1973
Screenprint
99 × 69cm

11 **Roy Grayson** (b.1936)
This postcard . . . 1970
Lithograph
9 × 14cm

22 **Murai, Maçanari** (b.1905)
Three faces 1958
Lithograph
66 × 51cm

Murai, Maçanari
Three faces 1963
Woodcut
66 × 51cm

24

*Gaston Petit: *Forty-four Japanese Print Artists* Kobansha International, 1973

GEDICHT	POEM	POEME
		6
28		
		25
10		
		45
12		
		19
75		8
5	258	3

Teil I Exemplar Nr

CHANGE	EXCHANGE	WECHSEL

	1650 F. F.	
125 D. M.		
	98£	50$

Teil II Exemplar Nr

POST CARD

For GIMOUR
THE TATE GALLERY
MILLBANK
LONDON
SW1P 4RG

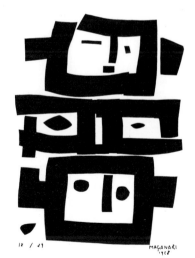

18 / 29
MAGANARI
1958

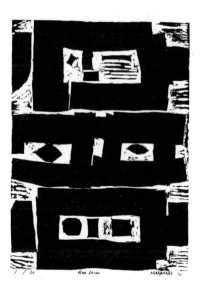

1 / 30 three faces MAGANARI '61

Prints and paintings on the same theme

It does happen that artists will treat an idea for the first time in print — Ben Nicholson, for example, made geometric linocuts before constructing his famous white reliefs. Because prints and paintings are so often segregated, little work has been done on such relationships. Frequently, however, artists re-state graphically ideas they have touched on in other media, yet use printerly qualities to deepen and even finally to resolve the theme. The Norwegian Expressionist, Munch, who thought his prints superior to his paintings, made some of his most deeply considered statements in this way. He was haunted by childhood memories of sickness and death, for his sister and mother both died of consumption before he was fourteen. *The Sick Girl* was a subject to which he continually returned after his first detailed naturalist treatment of 1889, with the invalid looking from her chair through the window at a radiant springtime which her wistfulness tells us she will not survive.

Following the revelation of French painting, Munch announced his programme for pictorially expressing states of mind by means of symbolic, emotionally charged forms. Re-stated in the austere tetchy line of the early drypoint of 1894 **(16)**, the suffering girl and her nurse are found enclosed in a tissue of claustrophobic shadow, edginess being given to the narrowness of the quivering space by a tiny pendant landscape suggesting organic freedom. In the colour lithograph **(17)** made two years later with the cooperation of the Parisian master-printer, Auguste Clot, the subject has been refined until only the girl remains. Wraith-like crayon strokes make the insubstantial body almost one with the supporting pillow, against which the yearning profile pales ethereally, a paleness made more terrible by the adjacent flaming of her vivid hair.

Even prints involving photomechanical process do not necessarily infer slavish imitation of pre-existing work. John Walker based several photographically derived prints upon a painted image of 1965 in which two leaflet forms levitate against a grid. Several diminutive etchings were spawned by it in 1971, then in 1973 the artist abstracted additional information from another painting for a major sequence of ten huge screenprints **(19)** (their serialisation a natural concomitant of print process) which in ravishing crescendo took one folded form from dim and ghostly trellises in white-grey mist to charcoal grids on darkening grounds of marbled dun and chocolate brown.

16 **Edvard Munch** (1863-1944)
The sick child 1894
Roulette and drypoint
63 × 45cm

17 **Edvard Munch**
The sick child 1896
Lithograph
53 × 70cm

19 **John Walker**
No.10 from 'Ten Large Screenprints'
1974
Screenprint
141 × 102.5cm image

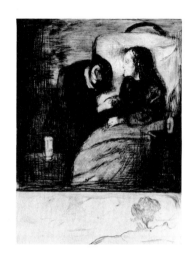

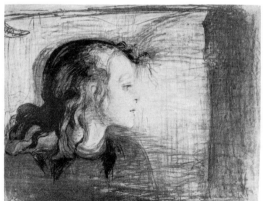

Print as print

The 20th century then, has seen prints daring to be themselves, under the joint banners of 'truth to materials' and 'originality' as well as by the gradual admission of photographically mediated images into the canon of aesthetic respectability.

A lightning tour of print's imitative history reminds us that early woodcuts were mass-produced manuscript illustrations and early engravings redolent of pen and silverpoint drawings. As engravers' attention strayed to painting, Giorgione's *sfumato* was approximated by Campagnola's powdering of stipple, until, following oil paint deeper into shadow, Goudt etched the longest black and white scale ever while mezzotinters aping low-key portraiture began with darkness and worked outwards to the light. Aquatints mimicked watercolour, the roulette made facsimiles of coloured drawings in the 'crayon manner', soft-ground emulated pencil. Prints even copied one another. Abraham Bosse proclaimed etching's duty was to disguise itself as engraving; lithography, rock-bottom in the hierarchy, impersonated everything. In the strangest masquerade of all, tonal wood engravings did their best to be photographs.

Although there have also been 'original' prints throughout history — to use trade jargon which means the artist personally fashioned the duplicating tools to communicate his own idea — it was only during the modern period that 'originality' crystallised in contradistinction to reproduction. Then Duchamp upset the applecart by suggesting that concept might be divorced from craft skill, while the Constructivists championed mechanical procedures in art which also severed intention from production. Such attacks on the nature of art and the purity of 'originality' entrenched the advocates of the hand-made in die-hard positions, loath to admit that technically 'original' prints could be rather boring, while photomechanical ones might innovate.

The 20th century print, whether the artist's manual skill is engaged or he delegates the final realisation to others, frequently exhibits independence of other media and a striking concordance between concept and form.

Ian Tyson, for example, used lengths of letterpress rule to create a visual counterpart for the halting stanzas of *A line that may be cut* (29) as movingly typed by its spastic author. *Birth of art* (28) by Tom Phillips, one of the sublimer examples of the indivisibility of idea and means, embossed into paper ten progressive erosions of zinc lettering stencils until the figurative 'ART' had become an unreadable abstraction, the stencils' dissolution a metaphor for the 20th century history of art.

Mixtures of techniques are increasingly used; Noda, Tetsuya, whose work is a running diary of his life, has made a bewitching photo-screenprint of his son (24) with the boy's own mischievous fingerprinted scribbles superimposed from the litho plate he tampered with.

29 **Ian Tyson** (b.1933)
A line that may be cut 1968
Letterpress
30.5 × 50.8cm

28 **Tom Phillips**
Birth of art 1972/73
Acid bitten zinc stencils, printed relief
26.4 × 58.4cm each

24 **Noda, Tetsuya** (b.1940)
Diary: September 1st 1974 1974
Screenprint with son's lithograph
46.5 × 64cm

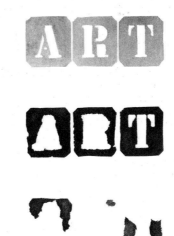

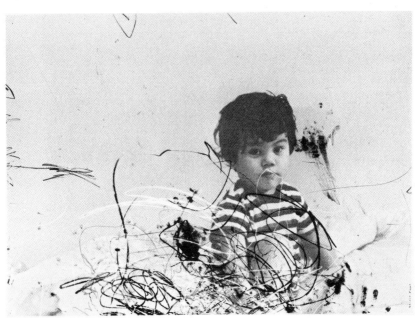

Fingerprints, so closely related to the idea of identity, were seen in a 1950 lithograph by one of the great graphic artists of all time — Picasso. Not only did he love graphic process for providing states which revealed to him the creative evolution of his ideas, but a graphic craftsman servicing his work had only to tell him something was impossible for it to become an irresistible incentive to do it. His prints, therefore, represent a constant rejection of the received opinions that lead to academism.

The fingerprinted portraits of his children *Claude and Paloma* (34), flesh of his flesh, were conceived for the cover of a book about his lithographs which he made for the printer Mourlot after a break of a year from using the technique. Since his lithographic ink had solidified in its container and he had no drawing implements handy, he simply added water and dipped in his fingers.

Picasso was equally the master of intaglio. 'The more technique you have' he once said 'the less you have to worry about it.' When, after Picasso's death Richard Hamilton was asked to contribute a print to a German portfolio in homage, he decided that he would pay tribute to Picasso's love and mastery of that medium.

In his own way, Hamilton is as subtle a technician as Picasso was, but understanding and analysis of photomechanical process is his particular métier, so although his prints frequently delight in a confrontation between the marks of the hand and those of the machine, the completely autographic print is less common in his oeuvre. It was therefore a courageous undertaking — dependent upon the cooperation of Picasso's former intaglio printers, the Crommelynck brothers — to choose Picasso's home ground for a print which, with typical Hamilton thoroughness, incorporated every conceivable intaglio technique from spit aquatint to soft-ground and sugar-lift to stipple.

Hamilton wittily chose to hang his idea (32) on the work of another Spanish painter, Velasquez, whose masterpiece, *Las Meninas*, Picasso had also paraphrased. It became a vehicle for pastiches of Picasso's successive styles in which the foreground figures appear as a Rose period harlequin, and in analytic and synthetic Cubist guises as well as Neoclassic elegance. Picasso himself, hammer and sickle on his heart, addresses himself to the easel in place of Velasquez.

32. **Richard Hamilton**
Picasso's Meninas 1973
Hard and soft ground, etching, aquatint, drypoint, engraving, punch, lift ground and stipple
57.5 × 49cm

34 **Pablo Picasso** (1881-1973)
Paloma and Claude from 'Picasso's Lithographs' **Vol. II** 1950
Lithograph
32.2 × 52cm

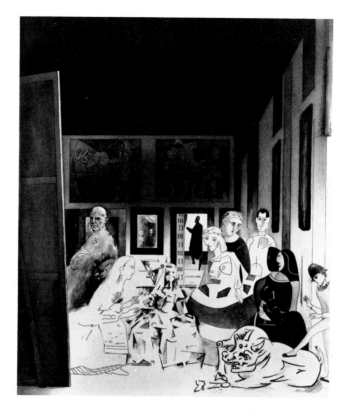

Joe Tilson's interest in Che Guevara was at its peak in the late 1960s when, in photographic vein, he made a number of celebratory images of political figures, many of which were concerned with the way they are presented to us through the media. One of the images of Che after his capture and death, which his killers intended to be monitory, in fact probably assisted his elevation into legend, if not into sainthood and martyrdom. It was inescapably in the tradition of Pietas of the dead Christ and Tilson was fascinated by its power and the way it had been transmitted to him from medium to medium. Even after it arrived in his hands, it had a varied graphic history, travelling into several prints and by way of an enlarged half-tone dot into some unique giant three-dimensional *Pages* in which text and illustrations screenprinted on pillows were set between intercolumniations made of wood. It was from an illustration of one of these works which appeared on page 39 of his photolithographed catalogue that Tilson retrieved the image for a photo-etching **(33)**. Suitably enough for a depiction of death, the darkest rendering of the face was achieved by a technique known as 'open bite' in which the surface metal is simply eroded and eaten away without any provision for holding ink during printing.

 The ingenious manipulation of half-tone — a kind of solarisation process capable of producing an infinite number of variations — was devised by the screenprinter's clever cameraman in response to the artist's request when working on an earlier print. Tilson remarks that this is an example of collaborative printing at its most integrated, for the technique would probably have remained undiscovered but for the simultaneous involvement of three people — cameraman, printer and artist.

 Tilson's later prints — the *Alchera* images (39) — reflect his family's move to the country and totally changed life-style with its shift from political and urban preoccupations and the technological optimism that earlier encouraged him to make multiples and work in vacuum-formed plastics. With their poetic cross-cultural references to earth, air, fire and water and other elemental divisions in nature, the prints reject plastic in favour of beautiful Japanese handmade papers. As the artist commented, the actual meaning of art may often be inherent in the materials and processes used.

 This meaning carried by the support itself has been a feature of the work of Roy ('I want to be blatant') Lichtenstein, whose ideas have always been 'about vulgarisation'. Famous for taking the subject of his paintings from strip cartoons — a fine art aesthetic based on mechanical print processes — he has also made series of landscapes on plastics, their refractory surfaces with moiré ripples suggesting sea or sky and completed with an aluminised moon. One of his 1967 prints **(37)** utilised a photographic sky, familiar dotted landscape and a fishy foreground in laminated textured plastic which gives actual dimension and an illusion of movement to the underwater scene.

33 **Joe Tilson** (b.1928)
Che Guevara p.39 1970
Photo etching
91 × 63cm

37 **Roy Lichtenstein** (b.1923)
Fish and sky 1967
Photo, textured plastic
and screenprint
28 × 35.5cm

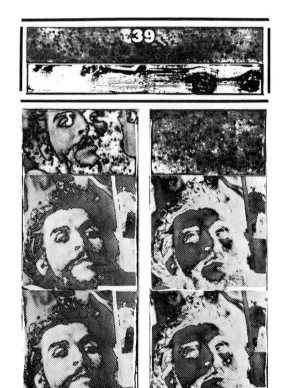

The medium becomes the image

The support has become the image, the form the print,
in Rauschenberg's *Pages* and *Fuses* which were made
at the 14th century paper mill of Richard de Bas in
France in the summer of 1973. 'I wanted each piece
to look like itself rather than something else', said
Rauschenberg, who had papermaking moulds
constructed from his drawings and then spooned dye-
coloured paper pulp into appropriate areas in the
moulds. Small screenprinted images on tissue (a
vertiginous look up a telegraph pole and a floating gull
in *Link* **(40)**) were added to the *Fuses* during making,
while their name came from the tendency of the colour
to bleed from one part of the print to another when the
paper was couched and pressed.

Robert Ryman has made a number of reductive
abstract images (41) — hell to print — at the Californian
Crown Point Press run by Kathan Brown. 'I am not
really interested in the idea of reproducing the same
image many times, says Ryman. 'My interest is in the
results that can only be achieved through the medium
itself, the actual process of printing, the ink, the paper,
and how to make the medium become the image.

Working in white on white (a 20th century tendency
which eternally evades Malraux's 'museum without
walls' by effecting irreproducible nuances) Ryman
punctiliously controls the exact location of signature,
serial number and any other elements in the print so
that the whole is the deeply considered sum of even the
most minimal visual components.

Perhaps the ultimate position in attitudes to autonomy
however, has been taken by John Murphy in his
Tagliare editions of boxed engravings (42). Reading
Tony Gross's book on intaglio technique, Murphy came
across intriguing instructions for cutting 'complete lines',
'half lines' and 'incomplete lines' (these differentiations
depending on how the engraver's burin leaves or enters
the metal). Though the work lies on the borders of
minimalism, Murphy was primarily interested in the
kind of lines he might obtain by following the
instructions. Having made three separate editions by
implementing each of the lines as directed, he
presented them not for distribution, but so that each
edition of nine prints with the plate used to print it,
became a single unique work.

40 **Robert Rauschenberg** (b.1925)
Link from '**Fuses**' 1974
Handmade paper, dye and screenprinted tissue
61 × 50cm

34

RELIEF PRINTS

From line to tone

During the centuries in which information as opposed to expression
was the dominating function of printmaking, the medium offering
greatest detail has usually gained most adherents. For illusionary
exactness, one must be able to handle simultaneously aerial and
textural perspective (the tendency for things to appear paler and
more finely graded at a distance) the undulation of surface in
addition to mere contour, and local colour as well as light and shade.

The first graphic artists — using knife and gouge on plank wood
— found it as much as they could do to render a schematic line.
For the most natural thing to do on wood (although achieving
Eric Gill's elegant arabesque **(43)** is hardly easy, since there's no
rubbing out) is to remove a negative line out of the dark printed
mass. To render positive drawings in wood involves a cut on each
side of every line, then excavation of the surrounding material.
Kandinsky, who moved from figurative folk art to non-objective
abstraction in the relief prints of *Klänge* (59), wrote on the subject
of a wood-cut dot: 'In order that the point may enter the world
(like a fortress with a ditch) it is necessary to do violence to its entire
surroundings, to tear them out and destroy them.'

Though charming and sometimes vivacious, the earliest cuts
such as *Melusina* **(44)**, one of the first book illustrations from
Strasburg, were with their stiff Gothic robes and borrowed poses
sometimes a trifle unbending. But to the modern artists attempting
to revitalise the medium by being 'true to materials', it was this
very wooden-ness that appealed.

Dürer set such standards, the intricacies of his crosshatching
involving myriad interstices to create the trellised lines (45), that
from 1550 few developments were possible, since the degree of
fineness was then also conditioned by rough paper and ink
dabbers rather than rollers. The ascendancy therefore passed to
more detailed metal techniques, except in ballad sheets and
broadsheets, cheaper and cruder forms of communication aimed
at the poorer classes.

The next step was taken in the late 18th century by Thomas
Bewick. Primarily a metal cutter, his daily round consisted mainly
of jobbing printing. His great discovery, which was to serve the
newly educated public reading the illustrated mass media, ousted
copper because of its type compatibility. He found that on much
finer end or cross-grain wood he did not need to cut round a
drawing in the conventional way, but could translate his designs
into delicate counterchanges of black against white and white out
of black, thought out in terms of the marks made by the various
tools themselves.

His illustrations to *The History of British Birds* **(46)**, with exquisite
vignettes providing a potted social history of his time, were
prepared by black-leading the back of his own tiny life drawings
and transferring them to blocks prepared with brick dust. His
printing was equally delicate, shaving down the block where it
was to suggest distance and lowering insistent edges at the
same time as pasting tissue to increase printing pressure at
points of emphasis.

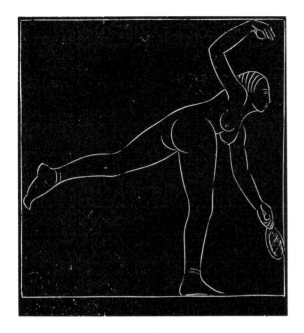

Wie beichtet Goffroy an dem totbeth. Und lieſ ÿm thon alle criſt-
enliſche recht mit allen ſacramenten. Und ſtarb da als ein gůter criſt.

Diiij

His pupils and emissaries carried his lessons to the Continent and the United States where he would have been amazed at their later application. At its most mechanical such wood engraving was used for the swift manufacture of outsize composite blocks in which a single picture was split up between a number of engravers to meet press deadlines. Whole schools of more individual engravers served the reproductive needs of armies of *Punch* draughtsmen while distinguished Pre-Raphaelites illustrating books and periodicals were served by such remarkable engravers as the Dalziel Brothers. While Millais was often appreciative, they were abused by Rossetti who prepared impossible drawings of crosshatched pen, pencil, body-colour and wash on the block and then complained it had been mutilated in the cutting.

Actually it was astonishing to what lengths engravers would go (possibly to the point of blindness, one suspects) to follow the cursive line of the artist's pen. An unused drawing on the block for *London* **(48.1)** by the prolific illustrator Gustave Doré shows what spontaneous freedom of gesture his engravers had to interpret in stern and less tractable wood. After reproductive printing had been down-graded by the original etching brigade, people stopped looking dispassionately at the considerable ingenuity engravers brought to their relatively thankless task. Doré was served by a host of engravers who often suited style to subject bringing a frivolous cursiveness to scenes of high-class gaiety **(48.2)**, or like Pisan in Dante's *Inferno* **(48.3)**, using the cooler medium of line ruled by the multiple tool to invoke an unearthly atmosphere.

'J'ai beaucoup de collodion dans la tête (virtually — 'I have a photographic memory') Doré, who made few sketches, is supposed to have said. As the 19th century progressed it would not have mattered whether this was the case or not, for photography (with the grey tonalities of which wood engraving tried desperately to compete) was capable of transfer to the block. Indeed, under the influence of the open air movement, Elbridge Kingsley, an American wood engraver dedicated to tone rather than line, toured in a specially built caravan which allowed him to photograph and transfer his subject direct onto a light-sensitised woodblock. He then remained in communion with nature to complete the picture, which in the case of *White Birches* **(49)** won him a gold medal at the Paris Exhibition of 1889.

The range of tones he was able to achieve with his minute tools on a mere 80 square inches of end grain wood is little short of miraculous, but by the 1890s the process half-tone had rendered him technologically unemployable, proving as Landseer's brother had punned, the 'foe-to-graphic' art.

48.1 **Gustave Doré** (1832-1883)
Block for Boat race from 'London'
drawn but not cut 1871
Woodblock
(detail)

48.2 **Gustave Doré**
Holland House from 'London' 1872
Wood engraving by Dorris
(detail)

48.3 **Gustave Doré**
Illustration from Dante's 'Inferno'
Wood engraving by Pisan
(detail)

49 **Elbridge Kingsley** (1842-1918)
White birches c.1889
Wood engraving from photo on block
(detail)

The return to primitive sources

Artists such as Gauguin reacting to the increasing fineness and tonality of work on wood ('like photogravure — detestable') and in keeping with his return to what he considered the purer and more primitive springs of inspiration, began to look for entirely new values in the cutting of the block.

In Gauguin's case, the blocks he cut when back in Paris to illustrate *Noa Noa*, his fanciful story of two years in Oceania, are a strange fusion of very obvious cutting with knife and gouge giving decorative counterchanges of black on white and white on black, plus the most sensitive needling and sand-papering of surfaces in areas such as flesh — an unusual combination of the sensitive and the bold.

In a fascinating article* Dick Field has suggested that Gauguin tried to emphasise the mysterious symbolism of his art (somewhat at war with the decorative elements) by seeking in his method of printing the woodcuts 'a semi-intentional lack of clarity'. Certainly compared with the very crisp editions later taken by his son (51), the smudgy off-register prints that Gauguin pulled himself are very different in quality and feeling, having more of the monotype about them and interesting to compare in their superimposition of earth colours with the personalised printing (though of a very different kind) that Whistler also effected. However, since Gauguin's printing press, reported by an Hungarian painter who had tea with him in 1894 at his Rue Vercingetorix studio, was nothing more than the application of his bottom on the uncertain terrain of his bed, it seems doubtful if he could have obtained other than these qualities by this method.

Certainly the right to use a printing block to create a uniquely individual work is in keeping with the art-for-art's sake philosophy. More didactic is Sickert's belief that:'The best and most completely equipped etcher is he who leaves the plate in such a state that a competent printer cannot fail to give adequate and uniform proofs.' This returns one to the essentially editionable qualities of the graphic media and to print-shop quality versus personal feel and variety.

The woodcuts of Vallotton (50) with their strong patterning and running blacks were an equally innovative contribution to the reassessment of graphic aims which went on in Paris in the last two decades of the 19th century, partly influenced by the Ukiyo-e print.

51 Paul Gauguin
Auti Te Pape (Les femmes à la rivière)
1894/5
Woodcut
20·5 × 35·5 cm

50 **Felix Vallotton**
Gust of wind 1894
Woodcut
17·4 × 22·2 cm

40

*R S Field: Burlington Magazine, September 1968

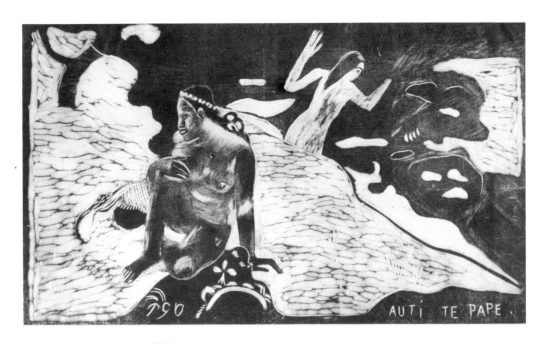

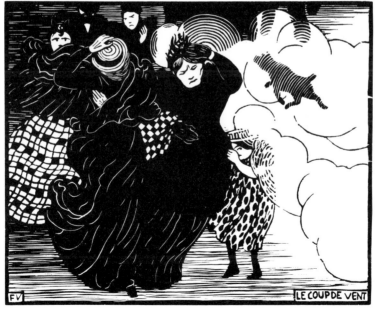

The heirs to these developments were the Expressionist generation — both the Fauves (Matisse (53), Derain and Dufy all cut strong blocks with primitivising elements) and even more Die Brücke who were returning to ethnographic sources and were influenced by ideas carried to them from Paris by Munch, with his ingenious use of plank grain (52), and jig-saw printing of colour.

Suddenly the plank with its knots and its tendency to splinter in the path of the gouge was very much in demand and Mueller **(56)**, Kirchner, Heckel (54) and Schmidt-Rottluff (55) not only made quintessential statements in the medium, but in their association, working like a medieval guild, used it as a means of illustrating catalogues, making posters and raising money for their artistic survival from lay members of the public who were given portfolios of prints. The autographic nature of printing was often stressed in a way similar to the images of Gauguin and Whistler, by treating the blocks like monotype surfaces and painting on colours which varied from sheet to sheet.

In Great Britain, wood was the medium accepted by bibliophiles as most appropriate for the illustration of books, and artists there looked to earlier influences but not necessarily the same as those consulted in Europe. Gill, for example, learnt much from Spanish Romanesque carving, Eric Ravilious from the dotted or *manière criblée* prints of the last quarter of the 15th century **(57.1)**, in which various shaped punches were hammered into soft metals in an early version of white line technique, offering a range of textures that Ravilious updated marvellously in his own delightful small-scale works **(57.2)**.

Post-war relief prints

In the post-war period, the market for small-scale prints in luxury illustrated books gradually grew into a market for larger pictures for the wall and relief as well as other prints in colour began to supply it.

A new medium — lino — was also pressed into service. Cheaper than wood, with less character and as a general rule, demanding coarser cutting, it seems to have been taken up first in the 1920s by Claude Flight and his Futurist-influenced circle (62). Matisse used it distinctively in the negative drawings he cut for *Pasiphae*, while Picasso, already 77 years old, yet showing the usual demonic inventiveness, generated entirely novel ways of cutting and colouring printing blocks (65) in a burst of work beginning in the late 1950s.

57.1 **Anonymous**
Christ on the Mount of Olives c.1470
Photo of *manière criblée* print
(detail)

57.2 **Eric Ravilious**
Owl from 'Natural History of Selborne' 1937
Wood engraving
7.2 × 10.2cm

56 **Otto Mueller** (1874-1930)
Mädchen zwischen Blattpflanzen 1912
Woodcut
28 × 37.5cm

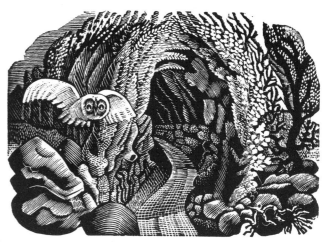

Michael Rothenstein didn't begin printmaking until the age of 40, but he looked back on his introduction to it as 'a second birth' and has always regarded it as a primary rather than a secondary medium. Following Schwitters, he saw the whole environment offered material for possible images and he was endlessly inventive in finding ways of printing them, subtleties of inking and packing giving his prints a precision and sophistication at which even the initiated marvelled. To traditional tools, he added tinman's snips, electric jig-saws and drills with wire brush attachments, making blocks of metal·scrap and plank weathered, burnt or warped.

'By using wood', he wrote in 1972, 'I found, in the earlier prints, a material that contributed an animal energy to the image. A section cut from a tree is a graph of frozen growth — the tree a vertical river of arrested sap. By conspiring with the flow of timber in forming an image, I felt in circuit with reality outside.'

In 1965 an accident with cooker cleaner on a lino-topped table apprised him of the fact that the granular surface of lino thus eroded, will print a kind of pseudo half-tone, allowing a colour nuance from a single inking. A gestural sweep on lino made with a housepainter's brush, was cut out and surrounded by huge fortuitous shapes of offcut elm to create the 3 × 5 ft. print *Black Orange Red* (**68**), which, among other things, celebrates the way in which true artists are capable of capitalising on a mistake.

Subsequently Rothenstein's work has combined relief printing and photo-images, and he has explored the differences between drawn lines and lines that have been photographed, hoping by combining material from very different directions to provide models which match in some degree 'the strangeness, richness and fabulous deversification of the electronic age in which we live.'

If *Black Orange Red* represents the apogee of a conspiracy with the components Josef Gielniak's linocut (**67**) finds a guiding principle other than 'truth to materials'. Self-taught and as a sufferer from TB working for long periods in a sanatorium in his native Poland, Gielniak, equipped only with a single burin and lino, imagined cosmological fantasies of the most ethereal kind. These, like Kingsley's wood engravings, seem to deny and perhaps transcend the earthbound materials from which they spring.

68 **Michael Rothenstein**
Black orange red 1965
Woodcut and etched lino
91.4 × 149.8cm

67 **Jozef Gielniak** (1932-1972)
Improvisation for Grazynka II 1965
Linocut
16.5 × 21.5cm

44

Brainwork versus mindless manufacture

During the second half of the 19th century, a very competent amateur, Sir Francis Seymour Haden **(71)**, conducted a campaign to elevate original etching, fired by anger that the Royal Academy admitted reproductive engravers to its ranks while failing to acknowledge original etchers. Art, said Haden, was directed by impulse from the brain, while the engraver, deprived of volition, copied other men with lifeless signs and formulae in mindless manufacture'. The Society of Painter-Etchers that he founded, adopted the motto: Do not stoop to copy.

Haden's God was Rembrandt, a 17th century forerunner of some aspects of the modern attitude. Rembrandt's search for dramatic mood and emotive chiaroscuro, evident between the first and fourth states of *The Entombment* **(69)**, as Christ's mourners are spotlit in their grief, exhaustion or resignation, was drawn directly on the plate. This spontaneity Haden extolled and himself tried to emulate. His prosletising did much to form the taste which lauded Van Dyck's personally etched portraits before they had been 'finished' by engravers according to the taste of his time. By the same token, Piranesi's imaginative *Carceri* was preferred to his literal Roman ruins, and Canaletto's trembling silver skies and Tiepolo's chopped and tossed *Scherzi* similarly answered the call for works obviously signalling artistic idiosyncracy.

Autographic freedom, resurgent in 19th century France as much as in England, reached its height in the tangles of etched scribble by Jongkind whose port scene **(72)** probably influenced the Monet canvas which gave Impressionism its name.

Even Ruskin, formerly a lover of detail and finish, reacted against the prints of the day. Writing a *Reverie in the Strand* about 'The Black Arts' in 1887, he admitted a change of heart: 'Now that everybody can mirror the thing itself, or at least the black and white of it, as easily as he takes his hat off, and then engrave the photograph and steel the copper and print piles and piles of the thing by steam, all as good as the first half-dozen proofs used to be, I begin to wish for a little less to look at.'

Sickert, weaving in the shadows (73), Braque and Picasso in their austere Cubist phase (74), Matisse with his exquisite illustrations to Mallarmé's *Poesies* (76) and Tony Gross with his lyrical treatment of the everyday and brilliant use of progressive biting to suggest colour **(75)**, were among the artists who appropriated linear simplicity to their respective styles.

71 **Sir Francis Seymour Haden** (1818-1910)
The towing path 1864
Etching and drypoint
(detail)

72 **Jean-Barthold Jongkind** (1819-1891)
Port d'Anvers 1868
Etching
15.5 × 23.5cm

69 **Rembrandt Harmensz van Rijn** (1609-1669)
The Entombment, states I and IV 1654
Etching, drypoint and engraving
16.1 × 20.9cm each

75 **Anthony Gross**
La charcutière 1932
Etching
19.2 × 28.5cm

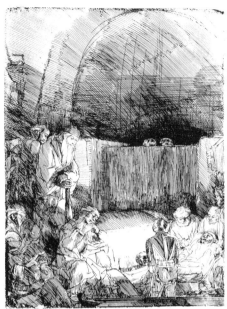

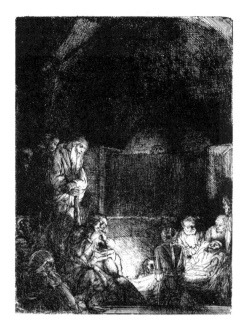

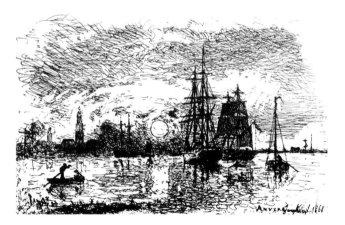

The 20th century began with fantastic popularity for etching, even in the hands of second rate practitioners; but only the best artists survived the Depression.

Many a subsequent print historian, particularly William Ivins, has followed Haden in adversely contrasting the heartless formal line of the 'impersonal' supposedly mechanistic burin, with the intuitive autograph seismographically recording the etcher's whim and temperament. But as Leo Steinberg remarked recently . . . 'The horror one generation strives to avoid is aspired to by another.'*

He declared that his eyes, attuned to the post-painterly outlook of the late 1950s, were delighted by the systemic disciplines and reductive conventions of the reproductive engravers and thought . . . 'those rigidities were less a matter for industrial efficiency and economies than a cherished preference.'

To Ivins, Mellan's head of Christ on Veronica's handerchief **(79)**, engraved as a continuous but variously weighted line spiralling from the centre of the face to the perimeter of the cloth, is an exhibitionist stunt. Yet a feat of supranatural virtuosity may be a valid way of communicating the miraculous, and the legend 'Formatur Unicus Una' applies as much to subject as technique. And while engravers from the 16th to 18th centuries are frequently lumped together as if identical in some imagined frozen perfection, there is a deal of difference between the solemn and limpid clarities of Mellan, who rarely crosses a stroke and the swinging moiré buttocks of *Hercules Victor* **(78)**, by a surely amused (and amusing) Goltzius.

Such was the reaction against the burin occasioned by Haden's adverse publicity, that the 1920s had arrived before Laboureur (80), Hecht and Hayter (110) managed to make the crystalline cut of the tool respectable again. Its exquisite line, quite different from that produced by etching, is seen at its purest in the apparently effortless elegance with which Hecht delineated animals and living things **(81)**.

81 **Joseph Hecht** (1891-1952)
**Ours blanc from
'Croquis d'Animaux'** 1929
Engraving
17.1 × 23.4cm

79 **Claude Mellan** (1598-1688)
Christ on the Sudarium 1667
Engraving
(detail)

78 **Hendrik Goltzius** (1558-1617)
Hercules Victor 1617
Engraving
(detail)

48

*Print Collector's Newsletter Vol. VI No. 4. Sept/Oct 1975.

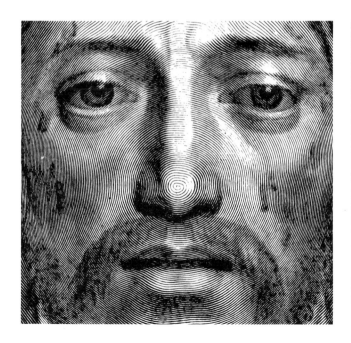

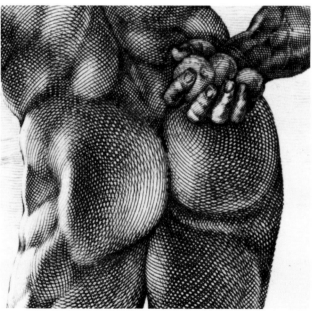

Cross hatching

Mezzotint, suited to dark portraiture rather than Hogarth's rococo touch, was in temporary retreat in England when he was at his zenith. In any case, he was always seeking the utmost expressiveness with the minimum of labour and aware, because of that, of his failure to attain the 'beautiful stroke on copper'. Hogarth is unusual in that until *Marriage à la Mode*, his paintings (from which he found he could make less money than by the subscription sale of his prints) served as the preliminary sketches for his own engravings. He thought character was 'best hit off with a quick touch' (deliciously loose and suggestive in the tickets he fashioned for subscribers). Fine engraving, he said, might price his moralising prints 'out of the reach of those for whom they were chiefly intended'.

Nevertheless he, as much as anyone, was subject to the prevailing requirement for grace and finish and although his own work on *The Harlot's Progress* **(83.1)** has been described as documentary realism in the equivalent of Swift's plain style, when he came to *Marriage à la Mode* **(83.2)**, and despite his disgust in the vogue for foreign rather than English artists, he employed French engravers to achieve acceptability, although perhaps he also thought that their polish was more appropriate for a tale of an arranged upper-crust marriage than had been necessary for the descent of a harlot from recruitment to coffin. At any rate, a comparison between his tonal net and that achieved by the professional engravers he employed, is the difference between outspokenness and measured phrases.

Down the ages, crosshatching has been used for a variety of purposes. One of the things David Hockney learnt from Hogarth (whose *Rakes Progress* he updated) was that crosshatching is a useful way of creating tone by line. He applied it not only to the sets of the opera based on the Rake, where it complemented the music beautifully, but to his interpretations of Grimms' *Fairy Tales*. A shivery scribble over the top of very geometric ruling makes an evocative setting for a ghostly attempt to cause a shudder in *The boy who left home to learn fear* (86).

The sculptor, Henri-Georges Adam, constructed his spatial engravings as abstract geometries on cut plates (85). Morandi's still-lives and landscapes are a continuous web of impassive hatching endowed with a curious timelessness (84). In the work of William Tillyer, very formal potentially afocal all-over etched grids create surprising pictorial spaces, their dynamic diagonals suggesting that matter and energy are interchangeable **(87)**.

Sol LeWitt, on the other hand, concerned with minimal systemic processes and first to define what he was doing as conceptual art, said the idea was the machine that made the work. The serial artist does not attempt to produce a beautiful or mysterious object, but functions merely as a clerk cataloguing the results of his premise **(88)**.

83·1 **William Hogarth** (1697-1764)
Ensnared by a Procuress
plate 1 of **'The Harlot's Progress'** 1732
Etching and engraving
(detail)

83·2 **William Hogarth** (1697-1764)
The Marriage Contract
plate 1 of **'Marriage à la Mode'**
(with J B Scotin) 1745
Etching and engraving
(detail)

87 **William Tillyer** (b.1938)
The large bird house 1971
Etching
(detail)

88 **Sol LeWitt** (b.1928)
Lines in four directions 1971
Etching
38.1 × 38.1cm

Mezzotint

Samuel Palmer, who almost painted with needle and acid the 'mystic enticement' of chiaroscuro adding 'gossamer films and tenderness' by surface tone and *rétroussage*, thought the charm of etching lay in the glimmering of the white paper even in the shadows (70). He disliked mezzotint which, 'like that cruel Othello puts out the light, eclipsing the sun before it closes the shutters'.

Palmer referred to the fact that in classical mezzotint, the plate, having been pitted laboriously all over with a subliminal cellular ink-holding structure is then scraped and burnished to win back the lights and half-lights.

An amateur discovered the process in the 1640s using a toothed roulette and an additive rather than the classic subtractive approach. The latter, employing a special toothed rocker, developed to serve the reproductive needs of Dutch chiaroscuro in the second half of the 17th century and, after a lapse, low-key portraiture by artists such as Reynolds a century later.

When the new steel plates came in early in the 19th century John Martin used them, for mezzotint throws up a burr like drypoint which accounts for the incomparable richness of its blacks but wears rapidly on copper. Reputedly designing direct on the new metal, Martin made several illustrations for *Paradise Lost* **(91)**, revelling in the appropriateness of the unearthly black for the eternal void and illuminating it with the light of the world. The viaduct over chaos is in a way reminiscent of civil engineering structures of the industrial revolution, while the cavernous depths suggest Brunel's first tunnel under the Thames, begun in 1824.

The 20th century has seen a remarkable international blossoming of the 'original' mezzotint. Merlyn Evans revivified it in astonishing large-scale abstract additive structures which he created with the mezzotint rocker in 1961 after acquiring a 44 inch press (92).

The medium's apparent inbuilt faintly surreal quality makes it as appropriate to the poetic strangeness of Hamaguchi's meditative natural forms (93), as to Dorothea Wight's tiny ambiguous windowscapes **(96)**, in one of which the exquisite addition of an etched silver window blind compounds the mystery.

Latterly, its likeness to a camera image (for ten times magnification produces no separable 'code' elements) make it an admirable vehicle for the American super-realist hand-making photos like Chuck Close. His gigantic portrait of *Keith* **(95)** (the whiteness of whose upper lip comes from early over-proofing) has the unctuous credibility of a photo portrait by Karsh of Ottawa. It was so huge however, that instead of hand rocking the preparatory structure, a very fine photographic half-tone was transferred to receive his handwork on the plate.

91 **John Martin** (1789-1854)
Book X, lines 312, 347:
The Bridge over Chaos from
'Paradise Lost' 1825/7
Mezzotint
19 × 27cm

96 **Dorothea Wight** (b.1944)
Window with blind 1975
Mezzotint and etching
15 × 13cm

95 **Chuck Close** (b.1940)
Keith 1972
Hand burnished, photo etched
half-tone structure
132.1 × 106.7cm

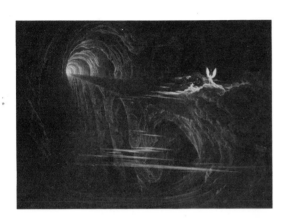

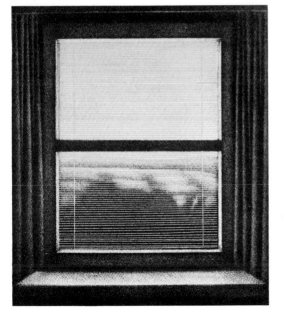

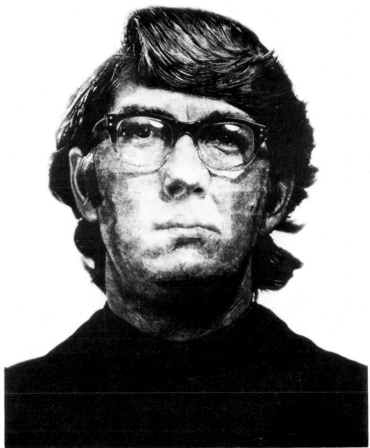

Aquatint

Whilst in painting or drawing an artist can immediately see the result of any stroke, all forms of markmaking in print are at one remove. For one makes not the mark itself, but only the means to create it and until the first proof is pulled, one may not entirely appreciate what has been done.

Moreover, not only is it often necessary to reverse the image so that it will orientate itself in the printing (thinking back to front) but one may have to conceive parts of it negatively (for example, painting a resist where you do *not* want the plate to print).

This is often the case with aquatint. Just as etching is a way of achieving a line by acid without the effort of pushing the burin through the resistant metal, so aquatint is a way of pitting the plate to print tonally without hours of direct work with a mezzotint rocker.

Aquatint really came into its own in the hands of the topographic watercolourists towards the end of the 18th century. The technique had also been ingeniously adapted in a variation called sugar-lift which allowed the positive mark of the brush to be recorded with comparative spontaneity. Thus Gainsborough, instead of negatively painting out the areas around his trees, was able to set down the trees themselves, much as he would have done in a wash drawing **(97)**.

During the modern period, this gestural immediacy (a concomitant of the stressing of autographic originality) has been developed to the point where a really practised artist will mix every conceivable intaglio technique on a sheet of metal, adding marks, or, more laboriously erasing them with sanding disc, burnisher or snakestone, with surprising freedom. Chagall's quirky self-portrait **(98)**, using drypoint for outline, aquatint as a middle tone and an acid resist for the negative delineation of skin and curls, was a trend-setter in the 1920s. Picasso's *Portrait of Vollard* (98), dated just over a decade later, displays similar devices as well as acid painted directly onto the aquatint — securing a more fitful effect than total submersion in the usual corrosive bath. Norman Ackroyd has created atmospheric landscapes by similar means (104).

Vollard was the entrepreneur who encouraged many artists of the Ecole de Paris to express themselves graphically, including Rouault. An expressionist with a medieval spirituality and a training in stained glass, a third of Rouault's large graphic output treated religious themes. His majestic artistic testament, *Miserère et Guerre* **(99)**, a suite of 58 plates on the misery of the human condition and Christianity as the only source of kindness, was one of the revelations of the mid-1940s.

97 **Thomas Gainsborough**
Wooded landscape
with herdsman and cows
Mid-1780s
Soft-ground with aquatint
25.4 × 33cm

98 **Marc Chagall** (b.1887)
Self portrait with grimace 1924/5
Etching, aquatint, drypoint
36 × 26.5cm

99 **Georges Rouault** (1871-1958)
Onward the dead
from 'Miserère et Guerre'
Printed 1927, published 1948
Lift-ground, aquatint, etching and
roulette on photogravure
58.5 × 44cm

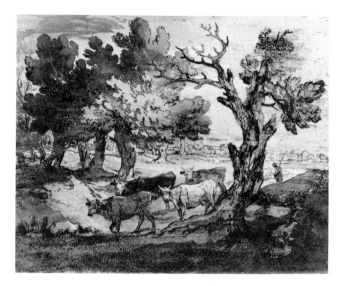

Rouault started the indian ink drawings for the portfolio at the beginning of the first World War, but proceeded too slowly for Vollard who took some of the preparatory works and had them transferred photographically to large copper plates.

Rouault disliked the results of the photo-process intensely, yet it acted as a spur, encouraging him to obliterate its traces with sugar aquatint, etching, soft-ground, deep bite, and even roulette, mezzotint and burnisher. He went at the copper plates, as he put it, 'hammer and tongs', and of some images produced as many as fifteen states. As an amusing sidelight on the originality controversy of the 1960s, it was actually suggested then that these plates were not 'original' because a photographic base had been used — one of the sillier excesses of a definition which tried to protect buyers by restricting artists.

The sugar aquatint was natural to the dramatic gestures of Emil Schumacher (102) (although little used by American Abstract Expressionsists). Later it became one of many intaglio devices used by Alan Green whose mutation and processing of major series of copperplates became from 1973 the actual content of the work (105). A recent intriguing use of aquatint, recalling Yves Klein's female body prints on canvas, was seen when Colin Self arranged a nude as a living mask to protect her own image from sprayed acid resist by lying across three huge copper plates **(103)**.

Perhaps the most ingenious of all intaglio printmakers however, was Picasso whose printers, the Crommelynck brothers, were astonished at the extraordinary technical virtuosity which allowed him to accomplish in a single operation feats which others might spread over several stages. Introduced to sugar aquatint in 1936 for the charming illustrations of Buffon's *Histoire Naturelle* (100), Picasso thereafter used the method frequently; but never so wittily as in the 66 tiny exquisitely wrought illustrations to *La Célestine* **(101)**, which were among the 347 engravings he completed in a period of seven months in 1968.

One of the first attributed stories in Spanish literature, the tragi-comedy of 1499 tells of the illicit and eventually doomed love affair between Melibea and Calixto masterminded by an avaricious duenna, turned procuress. Conveying flight by smirred grounds fused in solvent, Picasso, with piquant humour and astonishing draughtsmanship, teased and tickled plate after plate into shape with the voluntary handicap of grease in his sugar lift. Probably he had been told he must de-grease the plate. The whole book is a testament to the fact that tiny does not necessarily mean minor.

103 **Colin Self** (b.1941)
Figure No. 2 (triptych) 1971
Resist sprayed on aquatint using live model as masking device
162 × 62cm

101 **Pablo Picasso**
Illustrations for 'La Célestine' **by Fernando de Rojas** 1968
Etching, lift-ground, and aquatint
21 × 17cm paper size

Intaglio innovation

Traditionally relief and intaglio have implied two entirely separate
categories, in fact the opposite of one another. Relief prints are
made from the raised portions remaining after the unwanted parts
of a block are cut away; intaglio prints are made from the incisions
cut into the surface of a metal plate.

During the modern period however, the two have lost their
discreteness and the incision in a block or the un-etched relief
surface of metal, have been intermingled to the point where a
single print may be an impression into heavy paper of inked
and/or uninked portions of a multi-level matrix — such as the
American collagraph, so named in the 1950s.

Some of the earliest examples of this interchangeability are found
in delightful tiny wood engravings by Eric Gill which he printed
variously — from both the surface relief and from the incision (106).
But the real (and literal) breakthrough came when the German Rolf
Nesch, a student of Kirchner who escaped the Hitler regime by flight
to Norway, accidentally left an etching in acid too long so that he
had a hole in his plate. When printed, the damp paper was pushed
up under pressure into the hole, forming a bubble and thus adding
a palpable dimension to the paper. Since the Dadaists had already
elevated chance into acceptability as a procedure, Nesch harnessed
the accident for deliberate effect in the sparkling chandelier of *Café
Vaterland* **(107)**.

Penetrating the plate made him realise that he could also build
it up and this was the beginning of his metal prints, in which
first stitched and later soldered wires were used, as in the linear
silences of the *Snow* series **(108)**.

Later, as the troll-inhabited wastes of the Norwegian hinterland
in which he made his home impinged on his imagination, the
imagery became more and more fantastic and he combined etched
backgrounds with movable creatures formed of metal scrap,
soldered wires, meshes and netting (109). All were finger inked
with jewel-like touches of colour and embossed into a very heavy
hand-made paper, the editions, if that is the right name for them,
a succession of closely related variants. The very beautiful
printing plates were often made into 'material pictures'.

At his famous Parisian graphic studio, Atelier 17, SW Hayter, an
unusual combination of chemist and artist, made similar discoveries
a few years after Nesch. Thereafter he regularly deployed drilled or
carved hollows in his plates to create white lines or embossings in
the printed sheet **(110)**. These ambiguous, yet dimensional
manipulations of space, were sophisticatedly played off against
textures impressed into soft etching grounds and the vigorous line of
the burin, which he had helped Hecht reinstate. He exerted a strong
influence not only on the Ecole de Paris, but in America during the
war when Atelier 17 evacuated there and circulated his stern
interpretations of the meaning of 'originality'. From the late 1940s
he had a salutary effect on intaglio colour printing.

107 **Rolf Nesch** (1893-1973)
Café Vaterland 1926
Etching
19.6 × 24.5cm

108 **Rolf Nesch**
Landøen from 'Snow' 1933/4
Metal prints and plate
44.5 × 57cm

110 **Sir Stanley William Hayter** (b.1901)
Viol de Lucrèce 1934
Engraving, soft ground
21.5 × 29.5cm

A number of artists have developed Gill's experimentation with the intaglio printing of what is ostensibly relief in ways he could not have imagined. Two French artists, Louttre and Fiorini, have used intaglio methods to print gigantic murals from engravings on wood (111). The Japanese Hoshi, Joichi, contrasts the astringent wiry line of incisions in wood with the singular effects he achieves from the same material with acid and blow-lamp **(112)**. Birgit Skiöld, in an unusual book of poetry about Japanese Zen Gardens, surrounds photo-etchings of their imperturbable calm with borders of gouged lino printed blind and appropriately echoing their raked patterns (115).

Courtin hollows soft metal plates sculpturally, to as much as 2 mm in depth, to obtain a kind of cast in paper **(113)**, while Marjan Pogaçnik of Yugoslavia deep etches the hollows he intends to emboss with his plates, allowing his complicated sign systems to stand proud above the paper and sometimes applying the most delicately graded colours to the unbitten surfaces by tiny rollers **(114)**.

Just as these artists excavate their images, others build up the plate as Nesch did. Miyashita, Tokio combines etched plates with wood-block colour and in one particularly delightful concoction made soldered wire suggest dragonflies (116). In *The Wise and Foolish Virgin*, Agatha Sorel printed a readymade set-square combined with hammered brass strip and other materials. Several artists, James Guitet and Werner Schreib among them, have constructed printing plates from catalysed substances such as polyester resins, which can be manipulated with a spatula, combed, imprinted with natural forms and small machine parts, or impregnated into cloth, then used when hard (118, 120). Miro has used carborundum to provide 'tooth' in such pastes, welcoming the spontaneity it allows, and allying it with conventional intaglio techniques.

Maki, Haku whose chief medium is woodblock has applied sand, small stones, cement, or glue to provide a background texture, usually un-inked as a foil for the strong black superimposed ideograms (122).

This appreciation of the dimension achieved by the impression of bosses and hollows into heavy paper, makes it particularly appealing to sculptors. The Hungarian-French sculptor, Etienne Hajdu, devised one of its simplest forms when, working at Hayter's Atelier, he cut out shapes in zinc plate, arranged them on the bed of the press and printed them into damp paper to read white on white.

112 **Hoshi, Joichi** (b.1913)
Constellation 42 1967
Woodblock and print, printed from the relief and intaglio
77 × 60cm

113 **Pierre Courtin** (b.1921)
Ville de Cuivre 1958
Engraving
36.6 × 22.9cm

114 **Marjan Pogaçnik** (b.1920)
Untitled — two variants 1976
Relief etching, printed blind and with colour
11.5 × 11.5cm

What is particularly lovely about Hajdu's estampilles, as he calls them **(121)**, is the concordance between them and his three-dimensional works in polished white marble. It is not that the prints depend on the sculpture, but that he has found a perfect way of communicating a related aesthetic. For when the zinc shapes are compressed into a sheet of hand-made paper, its shadowy rugosities are smoothed away in the transit through the press and their embossed forms acquire a purity contrasting the remainder of the sheet.

Just as damp paper can hold a three-dimensional form, so sheet plastic can be vacuum-formed with similar effect. Many of the artists of the Pop era who welcomed plastics as new materials symbolic of the technological age, used them for editions. Tom Wesselman's cut-out nude on blow-formed vinyl **(123)** with her screenprinted tan and unsunburned strips was one of the more amusing examples. The difference between this vacuum-forming and an embossed print on paper is a matter of degree, but in the second half of the 1960s while the economy was still expanding, there was an efflorescence of a new art form known as the multiple.

Idealists claimed that the multiple (which most agreed differed from a print by being three dimensional) ought to be cheap, theoretically unlimited (actually an impossible concept) and made by mass-production processes. But multiples rarely got further than being a cottage industry, as Reyner Banham pointed out in an article on *The Aesthetics of the Yellow Pages*.* The majority of multiples were expensive and, in limited editions, proved themselves executive toys aimed as always at an elite.

Nevertheless the relief/intaglio overlap, the move towards the multiple, the blurring of all forms in the visual arts, with painted sculpture and shaped and projecting paintings, did itself provoke notable artists into a rash of three-dimensional print inventions. Richard Smith made many printed images using cut, folded, and later suspended sheets of paper. Many print ideas — bent back corners, the method of applying colour — fed back into his painted constructions. Leon Piesowocki made several prints of paper in star-like shapes suggested by origami **(126)**. Other artists combined layers of acrylic bearing more than one printed surface, or made illusory boxed constructions like Ivor Abrahams (125), who has also flocked prints creating dimension with a technique related to Victorian wallpapers.

Agatha Sorel, using an unusual pantographic technique on perspex, sent the engraved line off into space in a way as infinitely repeatable as an engraving on paper **(127)**.

121 **Etienne Hajdu** (b.1907)
L'Oiseau 1973
Estampille
52 × 43cm

123 **Tom Wesselman** (b.1931)
Cut-out nude 1966
Screenprint on vacuum-formed plastic
50.7 × 60.5cm

127 **Agatha Sorel**
Raft 1970
Multiple — space engraving on perspex by pantograph
20.3 × 20.3 × 60.9cm

*New Society Vol. 8. No.203 1966.

LITHOGRAPHY

The beauty of lithography, discovered at the end of the 18th century, is that a print made by the process is practically synonymous with an artist's drawing. All that is required is that the drawing made by a special form of grease (obtainable in various crayon or liquid forms) be deposited on a grainy surface — once upon a time a limestone slab, nowadays more probably a treated alloy plate. Every nuance, from the lightest touch to the heaviest solid, will be captured when the stone is prepared, the greasy drawing inked and the ink in turn imparted to the paper.

Indeed, the medium is so sensitive that the early lithographers, who tended to work by building up chalk in a minutely particularised way (such as Bonington **(129)**, who combined a French exquisiteness with English topographic taste) were warned not to let dandruff fall on the plate, since the grease from that, or from fingerprints or sneezes, would entirely ruin the effect. In more recent racy, chancy days, a fall of dandruff might be regarded as a gift from the gods.

Lithography is the medium which perhaps most inspires connoisseurs to rave about the colour in black and white; the range of tones possible is unbelievable.

Goya, and other great French draughtsmen of the early 19th century such as Delacroix, used the medium brilliantly. And since there was not the same need of middlemen to translate designs into dot and linear codes similar to those used for engraving (although of course there were reproductive craftsmen in the medium), it became increasingly likely that one would find 'original' prints in the workaday world of the illustration, the cartoon, and later the poster.

Daumier's brilliant satires — lampooning the king as a pear or socially commenting on the foibles of the bourgeoisie — were quite likely to land on the breakfast table with the daily paper. Thus the joke of the father discovering in the small hours that a baby is a yell at one end and utter irresponsibility at the other **(130)**, even now has the incisive freshness of a drawing straight from Daumier's own hand.

Although colour has been lithography's role since the late 19th century, some artists — Matisse among them — have always believed 'a colourist makes his presence known even in a charcoal drawing'. The majority of Matisse's prints, avoiding superficial charm with their intuitive synthesis of sensations from nature, deploy only black on white, the placement of the linear arabesques a matter of acute critical adjustment **(132)**.

129 **Richard Parkes Bonington** (1801-1828)
Tour du Gros Horloge, Evreux from
'**Voyages Pittoresques**' 1824
Lithograph
33.5 × 21cm

130 **Honoré Daumier** (1809-1897)
Crie donc, matin! guele donc;
plate 2 of 'Croquis d'expressions'
in Charivari 1938/9
Lithograph
25 × 35.5cm

132 **Henri Matisse**
Nu couché et coupe de fruits
(Arabesque IV) 1926
Lithograph
43.1 × 53.9cm

But drawing by wash is also natural to lithography. Indeed, anything that can be created on a sheet of special paper with litho medium (crayoning, painting, rubbing, or a collage of printed units) can be transferred to the stone or plate by simply passing it face down through the press. Thus the technique is a means of integrating on the printed surface a variety of effects that would be much more difficult to achieve in drawing, with the added possibility of scratching back from darkness to light.

Needles, razors, scrapers and sandpaper were the stock-in-trade of the 19th century lithographer. The German, Adolph von Menzel, who in 1850 made a series of *Experiments on stone with brush and scraper* achieved the most astonishing contrasts between the glistering blacks on the coats of steaming foreground horses and the tenderest grey of others disappearing into a distance, finely scratched to suggest a descending veil of misty drizzle **(134)**.

The Symbolists loved the tonal contrasts possible in lithography. Redon, working in 'the ambiguous realm of the undetermined' told Andre Mellerio in 1898, that any art of suggestion gets much from the reaction of the surface of the medium itself, a truly sensitive artist not finding the same image in two different techniques (131). Carrière, in a way which impressed the sculptor Medardo Rosso, liked almost to sculpt his portrait heads from the shadows, as if they and their ambience were one. Sickert pedantically complained that his oil portrait of Verlaine, because subtractively wiped, was 'hollow painting', producing concave rather than convex forms. Carrière's lithographs would not have satisfied this critic either, for the mysterious soft-focus penumbra is built up progressively by overprinting three stones, on each occasion carrying less and less transferred wash from one master lithographic drawing (135). This insistence on a reductive technique suggests the artist's interest in materialisation from the surroundings was profound.

Having made only a handful of lithographs previously, Picasso, driven by a lack of coal at the end of the war in 1945 to the warm Mourlot atelier, began a typically intensive period of work during which he sometimes put in a twelve-hour day. Coventional craft maxims left him unmoved; he broke all rules. Offered a mask to avert saliva, Picasso was likely to spit on the stone and somehow use the resultant whites. He also seemed to delight in metamorphosing images. A ferocious and solid bull was transformed in the course of eleven states to a few lines; the separate stones of a lithograph, originally intended to print in five colours, were each developed into a separate monochrome image.

In 1949 he produced, in wash thinned with kerosene, the exquisite drawing of a dove **(136)** — in Mourlot's opinion one of the most beautiful lithographs ever. On the face of it not a political image, it later became a Communist Peace Congress poster.

134 **Adolf von Menzel** (1815-1905)
Pursuit from 'Experiments on stone with brush and scraper' 1850/51
Brush, crayon and scraper lithograph
17.7 × 23cm
(detail on right)

136 **Pablo Picasso**
The dove 1949
Brush lithograph
56 × 76cm

OBJECT IMPRESSIONS

The tendency artists have shown during the modern period to embody actual things in their work, blurring the boundaries between illusion and reality, has an interesting parallel in print where the impression of an object is a tolerable substitute for the thing itself. In certain cases this possibility has answered the need for a 'mechanical' product from which the intervention of the human hand has, to all intents and purposes, been removed.

Dubuffet, for example, finds the traces of banal and disparaged objects — grass, dust — more extraordinary and exciting than Persian markets or snow-capped mountains. Since the things closest to hand are most often overlooked, he allows them almost to print themselves without the conscious control of the artist to impoverish the result, believing he thus achieves a primordially immediate pure image, 'impeccably raw'. Developing the technique first in 1953 with indian ink monoprints, he moved to lithography with tusche imprints on transfer paper and became so fascinated with the possibilities that between 1957 and 1962 in his specially acquired lithographic studio he originated the several hundred sheets of *Les Phénomènes* creating a library of textures from orange peel, chopped straw, bark, soil even. 'Seeing' he says, 'is being impregnated'.

Some artists have printed parts of themselves, a notable case being that of Jasper Johns who, after unusual preparatory drawings in which he adhered charcoal dust to the grease from his face and hands pressed on paper, adapted similar means to stone for a lithograph. Man's messy trace printed on translucent precisely ruled drafting paper is teamed with a typed poem by Frank O'Hara about the inevitability of the human condition **(141)**.

Most media can cope with the inking and printing of actual objects. Clothing has been pressed into a soft-ground and printed from the intaglio by Betty Goodwin **(142)**, or inked and squeezed onto paper in relief like Bernd Löbach's combinations **(143)**. Perhaps the most unusual method whereby an artist has allowed objects to print themselves was in Ed Meneeley's illustrations to Gertrude Stein's *Tender Buttons* (144). Composing with pins, rubber bands and buttons direct on the platen glass of a photo-copier, the silvery grey electrostatic prints — ghostly yet surprisingly suggestive of three dimensions — achieved a quality as delicate and tenuous as the poetry itself.

141 **Jasper Johns** (b.1930)
Skin with O'Hara poem 1963-5
Lithograph
55.9 × 86.4cm

142 **Betty Goodwin** (b.1923)
Shirt four 1971
Soft ground etching
79.5 × 60cm

143 **Bernd Löbach** (b.1941)
Muss die Hose Mitteilung Machen
1967
Material print
102 × 82cm

FROTTAGE

Max Ernst claimed to have discovered
'frottage' on 10th August 1925. It was a
method of random rubbing from the grain
of wooden floors, stale bread, unwound
thread or crumpled paper and was his
artistic equivalent for the Surrealist poet's
automatic writing. The technique, he said,
allowed him to be present as a passive
spectator at the birth of his own works.

Very much more artistry was required
to produce his *Histoire Naturelle* by
frottage than Ernst would at the time have
allowed. Nevertheless, ambiguously
blurring the categories of printing and
drawing, it then seemed a sufficiently
'mechanical' semi-automatic method with
which to shock the bourgeoisie.

Of course the technique was hardly
new. Since the 7th century the Chinese
have made rubbings **(145)**; among other
uses, pilgrims would copy edicts cut into
stone by placing paper on top and taking
an impression in sumi-ink.

Six years before discovering frottage,
Ernst submitted '*déssins mécaniques*' to
the Section d'Or and had them rejected
as 'not made by hand'. They were partly
rubbed from readymade technical line
blocks which he found in a Cologne
printer's shop. In 1936 the memory of them
inspired two sets of illustrations — for
Péret's *Je Sublime* **(146)**, and Breton's
Chateau Etoile. For these, frottages were
made into line blocks then editioned by
rubbing them with soft coloured crayons
— another form of mechanised drawing.
Rubbing similar elements onto transfer
paper meant the method could also be
adapted to lithography, which is how
*Etoile de Mer***(147)**, and many of Ernst's
other images were composed.

145 **Anonymous Chinese Rubbing**
Kuan Ti on horseback;
from 3rd year of Hung Che
Slab dated 1490, rubbing 20c.
115.5 × 55.8cm

146 **Max Ernst** (1891-1976)
by Benjamin Péret 1936
Illustrations for 'Je sublime'
Frottage
1 10.5 × 7.6cm 2 11 × 7.7cm

147 **Max Ernst**
Etoile de mer 1950
Lithograph from frottage
42.5 × 26.5cm

COLOUR

Relief Colour

While connoisseurs usually love monochrome prints and the range of tones from the wispiest grey to the most velvet black that great graphic artists can achieve, the most popular print is often the most colourful one.

Although there are exceptions — colours dabbed selectively onto different parts of the same plate, a merge of several applied simultaneously by roller or similarly mingled by the sweep of a screenprinting blade — in general, a separate plate and therefore a separate passage through the press is required for each shade. Different tones of a single colour may be suggested however, either by the gestural nuances of lithography, or by breaking the image down into dots or lines, in earlier days by hand and eye, latterly by photographic half-tone. Thus that which prints red from a solid area, appears pink when reduced in intensity by the intervening light of the paper — a fact brilliantly exploited by wood engravers like Edmund Evans in the 19th century.

For a long span of graphic history, black and white prints were vehicles for colour applied by hand, from the earliest block-books to Ackermann's topographic aquatint industry, which developed as the 18th century became the 19th century. For the mechanisation of colour (the three primaries plus black transparently overprinting each other to create the complete spectrum) needed the technology of the 19th century for its realisation, although in the early 18th century Le Blon made a spirited attempt to apply Newton's colour theory to mezzotint and recounted the principles in *Coloritto; or the Harmony of colouring in painting reduced to mechanical practice, under easy precepts and infallible rules.* Alas, balancing the amount of colour carried by each of the three plates, 'so as they cannot fail to agree', proved neither so easy nor so infallible as he had hoped.

The earliest printed colour pictures were from chiaroscuro wood blocks. Their flat and powerful generalisations were in vogue in early 16th century Germany until Dürer showed how to achieve colour using only black on white **(45)**. Partisan Vasari, claimed the Italian Ugo da Carpi discovered chiaroscuro, but the Germans Cranach and Burgkmair were both experimenting with it earlier, before the end of 1508. Like Dürer's virtuoso monochromes, the colour technique imitated drawings in black on toned paper with highlights touched in white — an equivalence being achieved by letting the white of the paper shine through one or two tone blocks and then printing a dark key block, sometimes self-sufficient, sometimes not, to carry the line **(148)**. The technique survived sporadically for about two centuries outside Germany.

With the lull in relief printing caused by the ascendancy of metal, it was not until the 19th century after Bewick had revolutionised cutting, that the colour woodblock was taken a stage further. George Baxter patented a method in 1835 (a meticulous technique for morally 'improving' subjects) in which engraved or lithographic keys were overprinted by 8-10 colour flats from skilfully registered wood blocks. Edmund Evans, working mainly in children's books by designers such as Kate Greenaway and Randolph Caldecott, interpreted them with masterly economy of colour and ingenuity of cut. In Randolph Caldecott's illustrations for *The Farmer's Boy* **(149)**, Evans packs an immense amount of information into a confined space by cunning deployment of vertical and horizontal lines made by the multiple tool.

45 **Albrecht Dürer** (1471-1528)
The resurrection from
'The Large Passion' 1510
Woodcut
27.5 × 39.4cm

149 **Randolph Caldecott** (1846-86)
Illustration for
'The Farmer's Boy' 1881
Wood engraving
by Edmund Evans
19.5 × 17cm

148 **Ugo da Carpi** (1450-1523)
Saturn, after **Parmigiano**
Chiaroscuro woodcut
45 × 43cm

Development of lithographic colour

In the 19th century it's hard to separate fine art from commercial lithographic practice, since autographic commerce became common. There are survivals of this overlap until after the second World War, at such pockets of enlightenment as the Curwen Press; technically there is no reason why it should not still continue, but for union restrictive practices which bar artists who have not served a craft apprenticeship from the shop floor. This means contemporary illustration is a matter of reproducing work in other media, rather than the artist working directly in print. The heyday of the autographic artist in the service of commerce however, was at its richest as the street poster developed.

Printed colour in lithography began in the 1830s with illustrations by TS Boys for books of picturesque architecture in which he imitated preparatory water-colours by lithographic means, drawing whites with weak acid on a groundwork of chalk, painting full tints with the brush, and rubbing tones **(158)**. Colour lithography burgeoned after the mid-century and was developed particularly vividly in Chéret's posters. Chéret, who to some purpose had studied colour in Watteau, Boucher and Turner's Venetian sunsets, devised that misty spatter later beloved of Lautrec, as well as the idea of selling everything from cough drops to Dubonnet by associating it with an ecstatically pretty girl **(163)**.

As commercial colour production was increasingly taken over by photo-process, the incidence of autographic limited editions grew, but the relationship between commerce and fine art is particularly interesting in the case of the Neo-Impressionists since their work had a scientific basis stemmimg from Chevreul's theory of colour published in 1839. Neo-Impressionist Divisionism (or Chromoluminarism) depended on the optical mixture of pure pigment following the separation of the elements — much as is the case in photo-mechanical colour printing. Moreover, their paintings as well as their prints show a quite fascinating kinship with pre-photographic efforts in colour lithography, in which, since fast machines made the natural half-tints of chalk impracticable on polished stones, pen stippling broke the colour up into dots of yellow, red, blue, pink and grey for the flood of Valentines, Sunday school texts and popular reproductions. Such works of popular culture bear comparison with the rather larger colour splashes in two blues, yellow and red with which Henri-Edmond Cross rendered his view of the Champs Elysées **(159)**.

163 **Jules Chéret** (1836-1932)
Folies Bergère — la Loie Fuller 1893
Lithographic poster
122.8 × 86.3cm

158 **Thomas Shotter Boys** (1803-1874)
Byloke Abbey, Ghent, from 'Picturesque Architecture in Paris, Ghent' 1839
Lithograph
26.5 × 37cm

159 **Henri-Edmond Cross** (1856-1910)
Aux Champs Elysées 1898
Lithograph
20.3 × 26cm

Ukiyo-e influence

The influence and ubiquity of print is nowhere better demonstrated than by the widespread effects of Japanese Ukiyo-e prints upon the modern movement in the West.

It's ironic (but very true to life) that prints which are the epitome of the despised division and fragmentation of labour for commercial ends, should have provided such a dramatic shot in the arm of art-for-art's sake, itself an emotional reaction to technology and materialism. For Ukiyo-e prints, no less than the rather inferior wood engravings for English popular papers (although without the same need for speed), were made by teams. First a publisher chose saleable subjects from the world of transient and sensual pleasures — prostitutes, actors, popular views — then an artist was commissioned to draw them with brush on thin paper. This was oiled to make it transparent and pasted face down onto the cherry-wood block, to be cut by specialists. Finally colourists painted on the rice-paste inks and printers hand-rubbed the impressions with barens into beautiful papers, churning out an average of 200 a day until the blocks wore out. Artificial rarity would have amazed the Japanese at this date.

Despite their subtlety, with refinements like uninked embossing, brass dust, mica, and lacquer gloss for sparkle, Ukiyo-e prints, perhaps the equivalent of our postcards or pin-ups, were not highly valued in Japan and they travelled to Europe as packing paper for porcelain. But in 19th century France and the England of the aesthetes, they were treasured as cultural examples from outside the western tradition, relatively free of the spatial concepts of the Renaissance, then under review.

Hokusai and Hiroshige, who excelled at famous views, became tremendously popular. In fact, it was Hokusai's manga sketches of 1819 that Braquemond, the etcher, found in 1856 and shared with Manet. Burty said Hokusai rivalled Watteau for grace, Daumier for energy, Goya for terror and Delacroix for animation. The spring-like colouring of his Fiji series **(160.2)** — blues with astringent greens — is echoed in sheets from Vuillard's *Paysages et Interieurs* **(166)**. Bonnard, 'Nabi très Japonard' on the other hand, was most influenced in *Quelques Aspects de la Vie de Paris* **(162)** by Hiroshige's obliquity and offbeat treatments, his representations of rain and darkness, and his clever interweaving of foreground and distance **(160.4)**.

160.2 **Hokusai** (1760-1849)
Inume Pass from **'The 36 views of Fiji'** 1823-31
Woodcut
24.5 × 36cm

160.4 **Hiroshige, Ando** (1797-1858)
Tsuchiyama from **'53 Stations on the Tokaido'** 1834
Woodcut
22.2 × 35.1cm

166 **Eduard Vuillard (1868-1940)**
A travers les champs from
'Paysages et Interieurs' 1899
Lithograph
25.5 × 34.3cm

162 **Pierre Bonnard** (1867-1947)
Title page from
'Quelques Aspects de la Vie de Paris'
1892
Lithograph
53 × 40cm

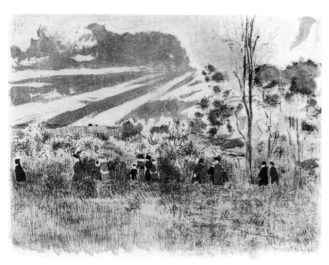

The Ukiyo-e sense of flat pattern, their asymmetrical composition and cavalier framing of a subject, their vaunting of aerial rather than mathematical perspective might have been devised to demonstrate the Nabis and synthetist conception of a picture as 'a flat surface covered with colours arranged in a certain order'. Equally liberating were their subtle colours, a number of which were once described as fishbelly white, eggplant white, rosy snow, bluish snow, heart of onion green, tea green and crab green.

Like Hokusai and Hiroshige, Utamaro was a great favourite, and Lautrec who even devised a signatory seal in the Japanese fashion, posed Marcelle Lender, geisha-like **(165)**, echoing Utamaro's helicopter hairdos **(160.1)**, while the tender eroticism of *Elles* may owe something to the Japanese artist's woodcuts of courtesans. Equally, the mask-like faces and characteristic poses of Ukiyo-e warriors and actors, whose shapes are immediately and dramatically evocative **(160.3)**, must have affected Lautrec's posters of performers: La Goulue with her helmet of blonde hair, *décolletage* to the navel and muslin drawers; Aristide Bruant's strong solid outline; and Loie Fuller, 'the electric fairy', dancing with veils which Lautrec dusted with gold in emulation of Japanese mica.

It was chiefly in the colour lithograph that the influence was felt, although Utamaro's work was much loved by Mary Cassatt, and inspired a series of colour aquatints. The Japanese pervasion also made Vallotton, Bernard and Gauguin take a fresh look not only at their painting, but at the black and white woodcut. Althouh he didn't descend to Japonism — the direct quotation of Japanese subjects — Degas, between Ukiyo-e and photography, learnt much from prints, and he adopted in his etchings such Japanese formats as the tall slim pillar prints, as well as their casual poses and idiosyncratic cropping. Van Gogh bought Japanese woodcuts before he went to France, copied several in paint and later chose to live in the Midi which, with its blossom was his substitute for Japan. Monet modelled a bridge in his garden after those depicted in his collection of Ukigo-e images. Few artists were unaffected.

165 **Henri de Toulouse Lautrec**
Marcelle Lender en buste saluant 1895
Lithograph
33 × 24.5cm

160.1 **Utamaro, Kitagawa** (1753-1806)
Act V from **The Chushingura series'**
Godamme After 1800
Woodcut
38.1 × 25.9cm

160.3 **Ikkaisai, Yoshitoshi** (1839-1892)
The Actor Kawarazaki Gonjuro 1862
Woodcut
35.7 × 24cm

The aftermath of Ukiyo-e

Many artists — Lepère is one — began applying colour washes
by brush to their woodcuts rather than rolling on an oil ink as
they had in the past. There is an astonishing sudden leap in
Lepère's work from very detailed white line cutting redolent of
high class picture paper illustration, to broad flat colour washes
brushed onto greatly simplified images such as the portrait of his
wife convalescing (161).

Well into the 20th century, Derain had the illustrations for
Pantagruel inked in the Japanese way, as did Miro, whose *A Toute
Epreuve* (151), based on the poems of Paul Eluard, echoes the
traditions of Ukiyo-e. One of the loveliest books of the 20th century,
the 233 blocks for its 80 illustrations were cut with the help of Enric
Tormo, their 42,000 passages through the press at Frélaut and
Lacourière taking over a year. Various wood grains were played
off against each other, and confections of collaged papers were
used as well as brilliant colours singing together — green, pink,
yellow, blue and red. Some of the blacks are partially starved in
a typically Japanese manner.

While the modern Japanese printmaker rejects the division of
labour common in Ukiyo-e and handles all his materials himself,
many artists from that country remain particularly adept at the
woodcut, and are extremely subtle in the application of colour.
Tajima, Hiroyuki applies oil to blocks the surface of which he has
built up unevenly with paper strengthened by shellac. Then he
floats a watercolour on the paper in the unprinted spaces within
the image (156).

The use of paper and cardboard for blocks, is very suitable for
the impecunious student as Lynne Moore found (152). It was the
American Ed Casarella who, employing cardboard and other
materials, formulated the motto: 'If you can ink it, you can print it.'

Japanese prints — both traditional and contemporary — have
been particularly popular in the United States where, despite, or
perhaps because of living in the most mechanised of countries,
printmakers have latched onto the strong element of individuality,
hand-crafting and aspiration for uniqueness common today among
the Japanese.

Hagiwara, Hideo has sometimes printed the paper on both sides
to get special effects as the ink soaks through. An echo is found in
the huge colour woodcuts of the American, Carol Summers, whose
imagery is based on mountain landscapes. He cuts blocks which
are never inked, since the colour is applied by roller merely using
the wood underneath the paper as a former to control the shapes.
This is not technically far removed from Chinese stone rubbing or
Surreal frottage, except of course that Summers does not employ
ready-made forms. He gives a highly individual finish to the image
by spraying a solvent onto the sheet of lovely hand-made paper
after application of the ink to soften and fuse the edges of the
colour (154). (See next page.)

161 **Auguste Lepère** (1849-1918)
La convalescente (Mme Lepère) 1892
Woodcut
40.6 × 28.8cm

151 **Joan Miro**
Page 11 from 'A Toute Epreuve'
by **Paul Eluard** 1958
Woodcut
32 × 50.4cm

156 **Tajima, Hiroyuki** (b.1911)
The six buttons 1971
Built up woodcut
56.5 × 42cm

Mizufune, Rokushū is another contemporary Japanese who paints his blocks using very heavy water colours thickened with Chinese white which he builds up into an impasto (157). Each of his images is uniquely hand-coloured, so there are no identical editions. On the other hand, Mersad Berber of Yugoslavia prints small editions, but in hand painting his blocks builds up nuanced layers so rich that the results suggest coloured and gilded Florentine leathers (155).

Michael Rothenstein is one of those rare artists whose international reputation has stemmed from prints rather than from unique works — a difficult feat even in this century, since the market is so oriented in favour of the latter.

He made his name with striking relief abstracts in the early 1960s but he is also a remarkable and much-travelled teacher who has consistently argued for the integration under one umbrella of techniques so often segregated in the art school. 'Each technique in printmaking' he wrote, 'is like a single instrument producing its own range of sound, but these instruments need not always be played separately, as they have in the past'.

Love Machine (153), embodies this philosophy, combining the complete repertoire of relief surfaces with stencilling of intense pure reds and blues progressively intermixed, the shapes related to the dazzling silver surround from metal factory scrap. At the heart of the print is a zinc half-tone made from a newsprint picture (rescued from a copy of the *Daily Mirror* that the butcher was about to use for the Rothenstein family joint) in which a photographer is reflected in the pupil of a starlet's eye. Discussing woman as a display object in *Love Goddess Assembly Line*, Marshall McLuhan wrote that the media view of the human body was as a kind of love machine capable merely of generating specific thrills. Rothenstein's use of a mechanical eye reflected in a human one does lead to a consideration of the way a received image detaches optical experience from the other senses. At the same time, in demonstrating the enlarged means of expression available to artists, he suggests, like Hamilton, the reciprocity and reconciliation possible between the human and the mechanical.

154 **Carol Summers** (b. 1925)
Fonte limon 1967
Woodcut
124·5 × 94 cm

157 **Mizufune, Rokushū** (b.1912)
Shade bone cut 1964, printed 1972
Woodcut
53 × 38.5cm

153 **Michael Rothenstein**
Love machine 1971
Metal waste, photographic
half-tone, woodcut
66 × 71.5cm

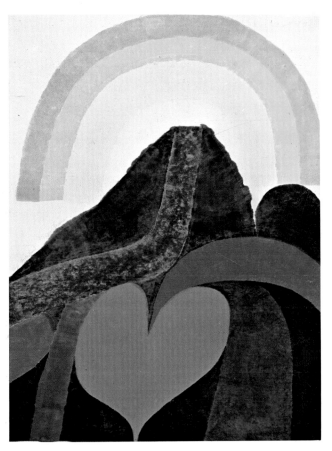

Intaglio colour

Le Blon's colour mezzotint proved so fickle that the
topographic ventures of the late 18th and early 19th
centuries tended to concentrate on monochrome aquatints
which were then hand coloured. Ackermann's *Microcosm
of London* **(180)** is a typical work from this period in
which, once again, division of labour is the order of the
day. For while Rowlandson and Pugin shared the etching
of the figures and architecture respectively, professional
aquatinters, J Bluck was one, would add tonal gradation
to the basic printing; then touches of colour would be
added by rows of children or women following the artist's
hand-coloured specimen.

In intaglio, as in other techniques, colour can be
antithetical to spontaneity. The traditional way of
producing it is to make a separate plate for every shade
required, a tedious matter of separation, registration,
and calculation of the amount the dampened paper will
shrink on drying, or stretch on each passage through
the press. The image must also be reversed for printing.
Rouault, making his own sugar aquatinted black key
plates personally, delegated to his printer the task of
filling in colour to his specification **(181)**. One of the
black proofs would be overpainted by the artist, then
Lacourière would imitate this infilling (akin to the stained
glass technique in which Rouault was trained) by several
colour aquatint plates in which the printer's skill was
such that even the artist's brushmarks were imitated.

It was to side-step registration difficulties, and to glorify
'original' creation that Hayter spent many years in his
intaglio workshop perfecting colour printing. First he
offset colour onto the wiped surfaces of an already inked
intaglio plate; later he devised a means of printing colour
by only one passage of the plate through the press. Since
he evacuated to America during the war, his ideas,
many of which proceeded from ethical considerations
suggesting the artist must do his own work, had
tremendous circulation and influence.

Cinq Personnages was a notable image of the
mid-1940s in which he solved some of the problems
inherent in his first method. In 1957 however, he took a
major step towards a more integrated impression. The
principle behind his new discovery lay in a multi-layered
deep-etched plate on which rollers of differing elasticity
— soft to sink low, hard to ride high — could deposit ink
of varying viscosities at different levels, the colours
blending as the plate passed through the press.

180 **Thomas Rowlandson** (1756-1827)
with **Augustus Pugin** and **J Bluck**
Bartholomew Fair; pl.8 from
'The Microcosm of London' Vol. 1 1808
Hand coloured etching and aquatint
19·3 × 26·2 cm

181 **Georges Rouault**
Christ et les enfants from **'The Passion'**
by André Suarès 1935
Aquatint
30.5 × 21.3cm

Bartholomew Fair; pl.8 from
'The Microcosm of London' Vol. 1 1808
(detail)

Pelagic Forms **(183)**, was one of his later applications
of the technique. So successful was the method
considered, that it revolutionised the look of intaglio
prints for a decade, and since Hayter was an
outstanding teacher and kept open house at Atelier 17,
generously exchanging and sharing the results of
indefatigable experimentation, it spread like wildfire
from Bahrain to Bangladesh.

Some artists have always found such colour intaglio
too self-consciously devious for their sense of urgency
and immediacy. Picasso, for example, stuck mostly to
black and white, although the Crommelynck brothers
(alas too late) invented an ingenious method of naturally
separating the colour stages in soft-ground etching for him.

David Hockney, who worked with the Crommelyncks
when he lived in Paris, became the natural inheritor of
this technique which is ideally suited to his propensity
for linear drawing in coloured crayons. It was partly
this process, partly the ingenious application of old
fashioned dolly printing with only two plates, that he
employed on the rainbow images of *The Blue Guitar*
suite **(185)**, this time printed by his English printer,
Maurice Payne.

Colour in post-war lithography

Lithography, following its resurgence at the end of
the 19th century, lapsed again until after the second
World War, when it touched new heights of popularity
in the hands of the Ecole de Paris and proved an
effective medium for gestural abstract painters, such as
Trevor Bell. The inks with their tender bloom can be
cast like transparent veils across one another, the intense
madonna blue in Bell's print beautifully modified
by neutrals **(173)**. The marks seem to have appeared
magically on the paper, rather than by tortuous
registration, simply because instead of mathematical
calculation the artist has accepted an element of
chance in their superimposition.

Before the second World War, you could scarcely
give an original print away. Despite its verve, there
were few takers for isolated projects such as Dufy's suite
La Mer **(167)**, which appeared in 1925. After the war,
however, several publishing houses (L'Oeuvre Gravée,
Guild de la Gravure) began to popularise original prints,
advocating a Braque, Picasso, Miro or Chagall original
as an alternative to photo-mechanical reproductions
of old masters.

185 **David Hockney**
Serenade from
'The Blue Guitar' 1976/7
Etching and soft ground
35 × 42.4cm

183 **Sir Stanley William Hayter**
Pelagic Forms 1963
Colour intaglio from one plate
36 × 44cm

173 **Trevor Bell** (b.1930)
Tidal objects 1958
Lithograph
49.5 × 36.5cm

167 **Raoul Dufy** (1871-1953)
Harbour scene from **'La Mer'** 1925
Lithograph
30 × 50cm

The popular print

A very early English venture nipped in the bud at the outbreak of war, was the attempt to bring good art to school children launched by John Piper and Robert Wellington. Paul Nash did one of his loveliest lithographs for them, the haunting *Landscape with Megaliths* **(177)**. There were equally memorable prints by Edward Bawden, Graham Sutherland and Piper himself.

Immediately after the war, Brenda Rawnsley took up the theme of pictures to 'guide children towards an understanding and appreciation of art' and, advised by Herbert Read, flew to France in 1948 to add to her British list the illustrious names of Braque, Leger, Dufy, Matisse and Picasso.

Picasso, encountered on the beach at Golfe Juan, liked the idea of an approach to children, and was intrigued by the new process offered him, which involved drawing colour separations on transparent grained plastic sheets for transfer to the litho plates by light. This surmounted the tedious business of registering drawings made on plates or stones. Immortalising Mrs Rawnsley by portraying her in her sunhat beside the tiny aeroplane, eating a melon **(178)**, he cunningly cut his signature out of the sheet carrying the main colour, promising to send it for addition to the printing plate only after approving proofs.

Absence of an additional pencil signature on the huge edition and prejudice against the innovative technique (now commonplace) usually excludes this print from catalogues of Picasso's work, although his involvement seems unquestionable.

As a postscript to the vagaries of the market place, and the public suspicion of a bargain, people failed to buy these prints when they cost a few pounds each, yet when they were later offered, with attendant publicity, at a grossly inflated price by a national newspaper, they sold like hotcakes overnight.

With the tremendous boom in prints, the suitability of gesture to the Tachist explosion and the styles of the most popular members of the Ecole de Paris such as Chagall **(171)**, the lithograph, with its rich colour possibilities and the sumptuousness of its washes, was in the ascendant throughout the 1950s. But in the 1960s lithography was overtaken by the screenprint — the only print medium developed in the 20th century. Admirably suited to colour field, hard-edge, geometric abstraction and the ready-made printed images of Pop Art, it dominated the art world in the following decade.

177 **Paul Nash** (1889-1946)
Landscape with megaliths 1937
Lithograph
49.1 × 74.2cm

178 **Pablo Picasso**
Composition 1949
Lithograph
46.5 × 76cm

171 **Marc Chagall**
Painter with palette 1952
Lithograph
61 × 48cm

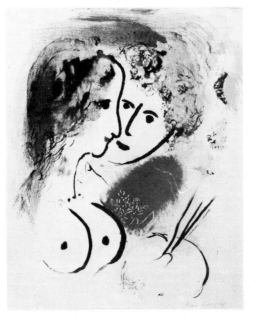

SCREENPRINTING

The stencil

Despite the fact that it is the only major graphic medium to emerge this century, it is as difficult to piece together the early history of screenprinting as to reconstruct 15th century relief printing from the incunabula of the woodcut.

Initially a fusion of British and West-coast American ideas applied to the mass-production of banners and signs, screenprinting's association with advertising probably explains why its fine art potential was overlooked for almost 40 years, until Pop Art started borrowing ideas from the media in a big way.

Throughout this period however, stencilling, the basis of screenprinting, with a tradition stretching back to the colouring of the earliest woodcut playing cards, was employed extensively. Called *pochoir* and common in France, it was cleverly adapted in the 1920s by Harold Curwen at his Plaistow press, after he had read Jean Saudé's book about it.

Most of Curwen's collaborating artists (Paul Nash, for example, in his masterly *Urne Buriall*) designed drawings to be printed as a key for stencilled watercolour washes. But the brilliant poster artist, McKnight Kauffer, conceived his illustrations as dense and resonant colour solids and indicated that the stencillers should edge-stipple them in gouache using a special brush. The memorable red-brick and emerald in *Elsie and the Child* (186) and blues as intense as those in early Italian tempera painting in *Robinson Crusoe*, make his book illustrations harbingers of the matte screenprinted colour that blossomed so vividly in the 1960s.

Kauffer's work precedes by nearly 20 years Matisse's stencilled masterpiece, the dazzling *Jazz* (187), in which images from travel, mythology and the circus suggest metaphors for artistic activity. At the time Matisse was preparing this book, between 1943 and 1947, experimental screenprinting by a group of artists led by Anthony Velonis (190.2) had been in progress in the United States for a decade or more, but had not yet permeated to fine art circles in Europe.

Echoing some covers he had made for the magazine *Verve* and so important in its implications for his magisterial late *papiers decoupés* and stained glass, Matisse's book was designed as collages which he cut — 'drawing with scissors' — from sheets painted in such brilliant gouache that when he pinned up his first efforts, he reached for his sunglasses. Printing inks then available were miserably unequal to this intensity, so that stencilling using the artist's own paint proved the only way of relaying his genius for the spatial manipulation of flat colour and his visual emulation of the 'meaningful cacophony' he had heard and admired in Satie's *Parade*.

186 **E McKnight Kauffer** (1890-1954)
'**Elsie and the child**'
by Arnold Bennett 1929/30
Gouache stencil on lithographic key
20.7 × 14.5cm

190.2 **Anthony Velonis**
6.30 p.m. 1938
Serigraph
35.5 × 26.3cm

187 **Henri Matisse**
Les Codomas from '**Jazz**' 1947
Gouache stencil
42 × 65cm each

Stencil to serigraph

While Curwen was introducing artists to stencilling, information about screenprinting circulated in the trade by such means as the tiny house journals of the Vase Press of Kettering, with their charming screenprinted covers **(188.1)**. Calling the new technique 'Vase-oleo' and describing it as oil painting by squeegee blade instead of brush, they proposed it for showcards and posters. Basically a way of adhering a stencil to a stretched porous textile, then often silk, the method avoided the crude ties and deviations of simple stencils and regularised the fine hair netting in those of the Japanese, by providing a continuous carrier for islands or delicate promontories in the design **(188.2)**.

The story of the medium's transition from commercial to artistic use begins in the States in 1932 with Guy Maccoy, who claims the first artists' screenprint exhibition (189). It was considerably later that Anthony Velonis, who wrote the first technical treatise on the medium, taught it to artists employed during the depression in the graphic division of the New York Federal Arts Project. Thus screenprinting rode in on a wave of enthusiasm for socially oriented works in public places and Ben Shahn was one of the distinguished Americans who used it during the 1940s (192).

One of its early champions as a fine art process was Carl Zigrosser, a print historian and curator from Philadelphia, who in 1940, in concert with Velonis, coined the name serigraphy (from Greek roots for silk and drawing) to distinguish 'original' screenprints from commercial production. Although this doubtless seemed politically expedient at the time, to win acceptance of a lower-class medium, in retrospect it looks like a belated attempt to separate yet again the fine and applied arts that William Morris, the Constructivists and the Bauhaus had so earnestly tried to homogenise. It immediately placed an editioning procedure in which the 5000th print is as good as the first, back into the exclusivity bracket.

The 'artistic' use of the medium departed immediately from the commercial, introducing 'hand-made' gesture via direct drawing on the stretched mesh. In England, Francis Carr claims he was among the earliest to employ it for an 'original' print (the 32-colour *After the Storm* of 1949 (193)) while the rubbed textures and transparent overprintings of his *Hungerford Bridge* of 1951 **(194)**, are typical of serigraphy at its most serigraphic. Then in 1956, there was a very early London studio set up by John Coplans at which several artists, among them Denis Bowen (196), Alan Davie (198) and Bill Turnbull, experimented with autographic abandon, the latter's *Head form* **(197)**, reminiscent of haboku 'flung ink' drawing.

In Canada, Alex Colville attracted by the ease with which a comparatively isolated artist could set up his own equipment, began his painstakingly detailed work in the medium in 1955 (195). But there was also considerable resistance.

188.2 **Japanese hair stencil**
Early 19th century
Stencil
(detail)

188.1 **Commercial stencils**
Vase Press Prospectus 43 1930
'Vase-oleo' screenprint
15·2 × 11·5cm

194 **Francis Carr**
Hungerford Bridge 1951
Serigraph
37 × 45.6cm

197 **William Turnbull** (b.1922)
Headform (black, yellow, green) 1956
Serigraph
77.4 × 57cm

Printer/artist collaboration

John Vince, currently writing a history of the medium, was at the London Working Men's College in the early 1950s where he taught Chris Prater, destined to become one of the great screenprinters of the 20th century. John Minton was among many artists who told him at that time that screenprinting was 'a bum process'.

The medium really took flight only when the obsession with autography receded and, in the pro-technological spirit associated with Constructivism, artists accepted the benefits bestowed on them by master printers and began realising images they could not have made without them.

In Stuttgart, Domberger was exceptionally early in such collaborative enterprise, screenprinting from 1950 for his neighbour and former 'degenerate' artist, Willi Baumeister. It was the 1960s however, before England and America followed suit. For ironically, the American Serigraphic Society, having suffered a decade of Abstract Expressionist indifference, closed its doors in 1962 at the very moment that Warhol and Rauschenberg were introducing commercial aspects of the technique into their painting — trying, as Rauschenberg put it, 'to bring art closer to life'.

Abstract Expressionism's European equivalent — Tachism — had temporarily eclipsed geometric and perceptual abstraction, the resuscitation of which, together with Pop Art was to put screenprinting irrevocably on the map. For while the nuanced line so natural to lithography has to be laboriously approximated in screenprinting — in many ways inimical to gesture — the medium has unparalleled ability to deposit hard-edged areas of flat dense colour. While it matters who makes a gesture, it is hardly relevant who cuts the stencil for a red square.

Unlike all older techniques, screenprinting has no history of black and white and has always been a vehicle for colour — take Ay-O's spectrum-ranging picture of *Mr and Mrs Rainbow* (205), complete with removable figleaves. Equally, since there is no diminution in quality, no matter how huge the edition, the medium was also ideal for the large-scale publishing ventures of Dorothea Leonhart who, when the print boom was in high gear in the late 1960s, commissioned an edition of 10,000 from Hundertwasser. His sizzling and metallic colours, combined in fifty different variations, were used on the print *Good morning city* **(179)**. Since he bewails rationalism in modern architecture, it is ironic that this idea was communicated by a complex mass-production print technology stemming from the same ethos which produces our concrete boxes. The sophisticated data concerning its editioning is annotated on the image itself.

Predicting the death of elitist easel painting and among the first to use screenprinting extensively, Vasarely argued that artists should create prototypes for enlargement or multiplication — 'more generous and more human' — in which rarity of meaning was more important than rarity of object **(199)**.

179 **Hundertwasser** (b.1928)
Good morning city 1969/70
Embossed screenprint
62 × 85cm

199 **Victor Vasarely** (b.1908)
Bi-Vega 1974
Screenprint
114 × 79cm

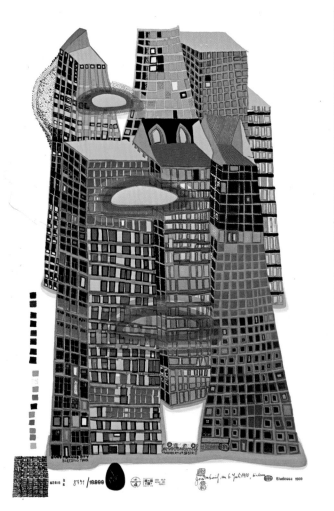

'It is no longer necessary to know how to do something, but how to have something done . . . Programming replaces empirical thought' he said.

Programming, suggesting remotely controlled automatons, gives little notion of the creativity of the printer in this collaborative situation, whose role is analogous to a conductor interpreting a composer's music, or an actor living the part in Shakespeare. For the technique produced men equal to the hour who seem certain to go down in the annals of inspired printing, among them the British printer, Chris Prater, sensitively solving such diabolic problems as the ink, which in drying altered the exact modulations required in Bridget Riley's *Nineteen greys* **(201)**, or the dynamic American, Ken Tyler, abutting Albers' squares with infinite precision (204), and when necessary building presses, developing inks, or custom-making papers. Tyler documents his prints as 'a collaboration between artist and staff'; he lives in a country which realises you do not get to the moon on your own.

Thus screenprinting produced a new genus of print. For whilst not 'original' in the traditional sense that requires the artist's personal handwork, neither were any but the laziest screenprints reproductive of fully formed drawings or paintings. They tended to be conceived in the terms of the medium, the artist providing verbal or diagrammatic instruction followed by production control. In fact, the situation Moholy-Nagy had postulated, of paintings which could be ordered by telephone from an enamel factory having been specified by graph paper grid and colour swatch, had arrived.

A rush of 'originality' definitions, invidious in their effect on the medium through tax and import laws, immediately broke out, implying the artist was morally bound to handle both craft and aesthetics. Since by this time some artists, including Riley, even painted by proxy (with excellent precedents from Rubens' production line and Reynolds' subcontracting of drapery) it was somewhat late to insist they humoured an outmoded concept by hand-crafting stencils.

The matter crystallised in 1965 when Patrick Caulfield at the Paris Biennale des Jeunes showed his witty deadpan cliché images, as from an infant's painting book, conceived for screen process and ideally suited to it with their smooth colour flats and bold black outlines **(207)**. Purists insisted (since Prater cut stencils using drawings which Caulfield made specifically to calculate the exact effects) that the work should be segregated so as not to contaminate the 'hand-made' prints — a time honoured practice known as shutting the door after the horse has bolted.

201 **Bridget Riley** (b.1931)
Nineteen greys A 1968
Screenprint
76.2 × 76.2cm

207 **Patrick Caulfield** (b.1936)
Bathroom mirror 1968
Screenprint
77 × 93cm

PHOTO-TECHNOLOGY

The line block

Although screenprinting finally completed the integration of photography with fine art, the photograph's initial alliance with printmaking was a purely reproductive one, usually translating a black and white drawing without tonal transitions into relief metal; mechanising, as it were, the mass media wood engraving.

William Blake's relief etchings, although naturally hand-made, set an interesting precedent. They looked forward to process line cuts, yet back to medieval block books. He devised, very early, a way of transferring his design as an acid resist to metal that was to be deep-etched. Investing technique with almost mystical significance, he spoke of this corrosive 'infernal method' as an appropriate means of 'melting apparent surfaces away and displaying the infinite which was hid'. This integration of his own illustration and hand-written verse is paradigmatic of his philosophy that a man's body and soul should be undivided (208).

Although subsequent artists did not manage quite his fusion of thought and process, a few showed subtle understanding of the possibilities of the line block. Aubrey Beardsley, disappointed with the foggy half-tone reproduction of a wash drawing and influenced by prints from Paris and Japan, designed the *Salome* illustrations as a sublime interplay of lines and solids **(209)**. In his later rococo embroideries for *The Rape of the Lock* he created tone in his line blocks by flurries of pen stippling.

Other brilliant users of photo-technology were the Germans, Max Ernst and John Heartfield, who employed despised commercial processes as anti-art gestures, overturning conventional values by thinking of their respective collage novels and photo-montages not as unique works for reproduction, but simply as means to a printed end. Indeed, printing helped to unify their disparate materials, concealing secret origins; photography thus found a new poetic use in verifying absurd or contrived situation with apparent truth and logic.

Ernst introduced alien matter into ready-made wood-engraved illustrations often taken over whole from bourgeois melodrama, allegedly sidestepping conscious thought, yet engineering mind-blowing surreal encounters between incompatible elements in surprising settings **(210)**. Heartfield, rejecting Bohemian self-expression by calling himself Monteur Dada in identification with blue-collar workers, mercilessly attacked the Nazi regime in political satire. His very conscious juxtapositioning of luxury products alongside the indigent, exposed capitalism or the connection between commerce and militarism in images alas, as pertinent now as when he made them **(211)**.

209 **Aubrey Beardsley** (1872-1898)
The woman in the moon (frontispiece)
from **'Salome' by Oscar Wilde** 1894
Line block
17.5 × 12cm each

210 **Max Ernst**
Une Semaine de Bonté, Book III
La Cour du Dragon,
1934
Line block
27.2 x 21.8cm

211 **John Heartfield** (1891-1968)
The Finest Products of Capitalism
from **'33 Fotomontagen'** 1932
Photo-litho after montage
50.7 x 36.4cm

Spitzenprodukte des Kapitalismus

Brautkleid für 10,000 Dollars　　　　　　　　　　20 Millionen Arbeitslose

Photo-screenprinting

Screenprinting however, outstripped all previous print photo-technologies in unifying and perfecting collage conceptions. Artists wanting poetically to associate a variety of elements (particularly those pre-processed by the media) indulged themselves as never before, once photo-screenprinting, patented as early as 1915, became general in the late 1950s.

Eduardo Paolozzi, for whom collage, in two or three dimensions, is a way of life, was quickly sensitive to the medium. Studying Surrealist documents in Paris in 1947, he saw how tatty auto-destructive papers collaged together with ill-considered glues could become. An inveterate collector of printed papers, his was the fascinating counter-culture epidiascope lecture at the Institute of Contemporary Arts in 1952 which is often cited as the kicking off point for British Pop Art. The images from popular culture he then projected reappeared in many of his prints, one of the attractions of screenprinting being the smooth way that this visual pot-pourri of engineering diagrams, Woolworth tablecloths, Michelangelos and Mickey Mouses, or scientific apparatus wreathed in weaving patterns, could be transposed onto a single plane **(214)**.

Paolozzi's first masterpiece was *As is When*, a suite based on the life of the philosopher Ludwig Wittgenstein, an eccentric emigré for whom the artist had considerable fellow feeling. By 1965, he and Prater were an inspired team and parts of the work were self-engendering when reject prints were cut up and made into viable alternatives (12). This imagery proved so fruitful that part of it has resurfaced a decade later in a set of woodcuts (13).

Someone said of Paolozzi that he matured at precisely the moment that genteel middle-class ideas about art most needed a knee in the groin. Certainly the print conventions were beautifully overturned (identicality normally being the printmaker's proud boast) when by simple permutations of colour, every sheet in some editions was rendered unique. Using the resources of a master printer meant to Paolozzi not only achieving things he couldn't do alone, but accepting the artist was part of a technological society and not an anachronism. 'Nobody expects an aerodynamicist to build his own wind tunnel' he said in 1967.

On two other artists — Joe Tilson and RB Kitaj — Prater had an equally radical effect. Both were introduced to the process as the result of the ICA print publishing venture arranged by Richard Hamilton and involving 24 artists in 1963. Tilson, who has made some of the most striking images in the medium **(218)**, sat down at one time, listed all the things one was not supposed to do in print, and did them. He, as much as anyone, blurred the barrier between unique and printed works, adapting the process to all sorts of materials and adding unusual appendages. Kitaj, also working primarily from a collage base, combined abstract and figurative imagery, introducing allusions not from popular culture, but from esoteric and recondite sources in his own reading — although elements which seem to have intellectual rationale, often prove to be there for purely visual reasons **(215)**.

214 **Eduardo Paolozzi**
Selection from **'Moonstrips and Empire News'** 1967
Screenprint
37.7 x 25.2cm

215 **RB Kitaj** (b.1932)
The cultural value of fear, distrust and hypochondria from **'Mahler becomes politics, Beisbol'** 1966
Screenprint
42 x 68.5cm

218 **Joe Tilson**
Ho Chi Minh 1970
Screenprint with wood and collage additions
101.6 × 68.5cm

Hamilton himself is among the most intelligent graphic artists of the century. Sampling each of the world's great printers has been almost a fetish, enabling him to widen art's sphere by the analytic exploitation of every conceivable technique.

Subtle manual intervention in 'mechanical' procedures has been a recurrent strategy through which he has demonstrated that, in art as elsewhere, machines are extensions of man, the most automatic processes needing brains behind them. Given an idea, a 'mechanised' print, no less than a gestural brushmark (but ideally a balance between both) may prove a vehicle for feeling, even for moral indignation.

And stylelessness is a myth. Despite the often alleged anonymity and impersonality of screenprinting, no one would have much difficulty in distinguishing his affectionate treatment of Marilyn Monroe using photographs she herself cancelled **(213)**, from Andy Warhol's endless serialisations, both on canvas and paper, of her mask-like make-up garishly misregistered over a photographic adumbration of her face **(216)**.

While some artists relish the camera's instant world view, others have been intrigued by its capacity for recording precise factual detail. John Vince, exploring a series of kitsch objects collected by John Furnival, used the camera to unfold hidden qualities in a thirties dish, revealing by over 40 printings every chip and roughness in the worn surface, even every crazing in the glaze (221).

The Super-realist, Richard Estes, delights, as the photographer Atget did, in reflections from across an urban street frozen in shop windows **(220)**. But however literal an interpretation the Domberger screenprint may seem, it was subject to almost painterly decisions and revisions. The Chinese lady in the left hand window gained and lost a fur coat sixteen times in the course of printing the 106 colours, and still looks faintly nonplussed.

It might appear there is nowhere to proceed to from such printerly accomplishment, but one may always return to square one. Kitaj, who has prosletised energetically for a return to depiction, especially via life drawing, recently announced* he was trying, with Prater's help, to draw direct on the screen — a technique Guy Maccoy, who started fine art screenprinting 45 years ago, has religiously adhered to. Artists being what they are, who can prophesy whether Kitaj's ambition will prove as reactionary as it now looks, or a great new beginning.

220 **Richard Estes** (b.1936)
Untitled 1973/4
Screenprint
80 x 120cm

216 **Andy Warhol** (b.1930)
Marilyn from **'Ten Marilyns'** 1967
Screenprint
91.5 x 91.5cm

213 **Richard Hamilton** (b.1922)
My Marilyn 1965/6
Screenprint
(detail)

* RB Kitaj — 'Chris — a note apropros' — *Arts Review* Vol.XXIX August 16th 1977

Hand-made stencils for light transfer

The vacillation between the hand-made and the lens-formulated image has been remarkably constant since photography was discovered and there are still those for whom any use of the camera implies a negation of art.

Ken Danby, the astonishing verisimilitude of whose *Early Autumn* **(225)** won him a popularity vote at the British International Print Biennale, regrets that the complexity of his screenprints, based on tempera technique, has caused people to misinterpret them as photographic reproductions. In fact, his images are laboriously hand-built, each stage being dictated by the last and each progressive a pen or brush drawing in opaque ink on transparent acetate later transferred to a screen sensitised to light. Such images depend on the artist successfully imagining the cumulative effect of colour.

In 1949, Henry Moore hit upon his own version of such a process (which he called collograph because he applied it to collotype) when he made colour separations on transparent plastic film allowing him to adapt the wax resist technique he made famous in his shelter drawings (224). Unlike lithography collotype was able to interpret the nuances of wash without half-tone. Diazo lithography, to which the sculptor has now moved, can do the same, but much is left to his printer to interpret, since the colours are extracted from a single monochrome drawing on a transparent sheet, rather than from a set of separations.

Although these hand-made stencils are fabricated for transfer by light to the printing master, rather than directly to paper, they have an historical antecedent in the cliché verre, itself a kind of stencil. First used by the mid-19th century French school which included Corot and Millet **(222)**, it entailed covering glass with a light-resistant coating and scratching through it, thus creating a hand-made negative from which to edition prints on the newly invented (but rather nasty) photographic paper. Although the images were certainly autographic, they never caught the public imagination. However, in 1959, Caroline Durieux revived the method in the United States and Jim Nawara's delicate aerial view of an imaginary earthwork **(223)** is among the images which have been produced at Wayne State University, Detroit, where a contemporary cliché verre school, including work in colour, has grown up.

225 **Ken Danby** (b. 1940)
Early autumn 1971
Screenprint
39.5 x 55.5cm

223 **Jim Nawara** (b.1945)
Horseshoe mound 1974
Cliché verre
35.5 x 45.7cm

222 **Jean François Millet** (1814-1875)
La précaution maternelle 1862
Cliché verre
28 x 22.5cm

Other photo-technologies

One wonders why the breakthrough that finally integrated photography with fine art came in screenprinting rather than lithography, for the latter medium established photo-technology far earlier and has been the conventional technique used for popular print reproduction. Possibly it was precisely that connection (living artists not wanting to be seen dead with old masters?) plus the wide gulf between autographic and mechanised lithography — in which, for example, a four-colour press can turn out 6000 sheets an hour.

However, screenprinting's lead, in the face of considerable establishment opposition as it flouted the 'originality' dicta, was followed by all the other media during the 1960s and one finds consistent tension during that decade between hand marks and those emanating from a machine, the 'machine' usually being a camera.

Even Picasso, the most manual of artists, was momentarily seduced by a found photo-lithograph on a zinc plate which in 1948 had advertised the *Peinture Lyonnaise* exhibition at the Tuileries and was waiting to be polished and re-used. He borrowed Victor Orsel's image, scratched some Pan-like figures out of the dark ground, envigorated the smooth transitions of the fine half-tone with bold lithograhic brushwork and editioned it under his own signature **(226)**.

There were even earlier attempts to knit process and autography together. John Piper in a book of aquatints of Brighton, begun just before World War II, suggested patterns of brickwork by photo-engraving typography onto his plate before beginning etching, an idea stemming from his inventive use of printed papers in collage **(231)**.

In producing *Axis*, the quarterly review about abstract art which he and his wife Myfanwy master-minded between 1935 and 1938 — Piper had turned his hand to everything, including colour reproductions in which he shrewdly teamed a single photographic half-tone with hand-cut relief blocks. The experience enabled him to conceive similar illustrations for the *Architectural Review* as prints designed in terms of the printing process. Since he was adept with a camera, it's not surprising that he was well to the fore in breaking down post-war prejudice against the use of photograhic images in art, utilising their rather literal ability to suggest the starkly formal qualities and severe philosophies of Welsh Non-Conformist chapels — such as *Llangloffan* **(227)** — in his free and inventive 1964 portfolio, *A Retrospect of Churches*.

226 **Pablo Picasso**
Italian woman (after Victor Orsel) 1953/55
Existing photo-litho reworked with
brush and white line
65 x 50cm

227 **John Piper**
Llangloffan, Pembroke:
Baptist Chapel from
'A Retrospect of Churches' 1964
Litho and photo-litho with plate
59.4 x 81.9cm

231 **John Piper**
Chapel of St George, Kemptown from
'Brighton Aquatints' 1939
Process engraving with etching
and aquatint
19 x 27cm

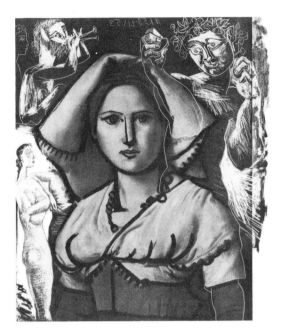

The Pop artists' interest in figuration was, Hamilton said, a 'return to nature . . . at second hand', a shift brilliantly encapsulated by Allen Jones in the suite *Life Class* **(229)**.

Recognising life drawing was no longer inevitably the artist's staple diet, Jones directed a sophisticated photographic session with a model whose variously posed legs, clad in pearlised stockings, were photolithographed onto the lower half of split sheets. The artist's powerful autographic contribution, informed by earlier hermaphroditic imagery and in competition with mail-order fetishism, supplied her ambiance and other accoutrements.

Across the Atlantic, Rauschenberg began lithography 'reluctantly thinking the second half of the 20th century was no time to start writing on rocks' when Tatyana Grosman virtually reintroduced the technique to America. Indeed, the medium's resuscitation, sustained autographically by June Wayne at Tamarind and somewhat cramped there by 'originality' definitions, was rather aptly described as 'bringing back the stone age'. It was Ken Tyler, quitting Tamarind to start the firm of Gemini in Los Angeles, who preached in 1965 that only a hybrid craft which adapted technology would survive.

In the recessive seventies, as opposed to the booming 1960s, the publications from Tyler's recently established East coast printshop have cut back from the optimistic technological multiple towards more exclusive, safer, often hand-coloured editions; but one recalls such stirring projects as the *Stoned Moon* lithographs with which Rauschenberg commemorated the 1969 Apollo moonshot **(230)**.

At that time, Tyler, leaving Rembrandt out of his calculations perhaps, equated large scale with importance. Two 89 inch upright images from *Stoned Moon* were the biggest lithographs ever hand pulled. However, ultimately they remain less memorable for sheer dimension than for the way Rauschenberg, delighting in printmaking as 'a cooperative creative yielding', put order into random juxtapositions from the 'real' world. Photographic images, some remote and machine-like, others appearing hand scribbled in a way recalling the artist's solvent and frottage *Dante* drawings — were integrated by gestural passages relating bird and rocket, man and technology.

Hand and machine again confront one another in the intaglio print from a brilliant suite by the Polish artist, Roman Opałka **(234)**. His systematically reduced details from a crowd photograph, collaged together then photo-etched, create a 'mechanical' population explosion at the heart of which the tiny figures of *Adam and Eve* are negatively hand burnished. The gradations of texture required three months' hand finishing; evidence, were it needed, of the artistry the word photo-mechanical may conceal.

229 **Allen Jones** (b.1937)
Life class 1968
Litho and photo-litho
83 x 56cm

230 **Robert Rauschenberg**
Hybrid 1969
Lithograph
detail

234 **Roman Opałka** (b.19315
Adam and Eve 1963
Photo etching printed in relief
58.5 x 48.5cm

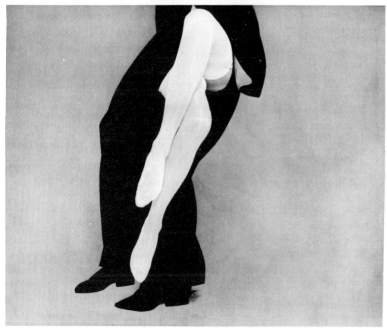

Photographs

The acceptance of photographs themselves into the domain of fine art (as opposed to their transposition into one of the more conventional print media) has been delayed technically by their fugitive impermanence on unattractive papers and psychologically, by both artists and public showing ambivalence towards anything straying from the hand-made.

Believing with Alvin Coburn that photography 'may do things stranger and more fascinating than the most fantastic dreams' Max Ernst in the early 1920s devised a photo print form which he called a 'photo-graphic'. *Santa Conversazione* **(235)**, was one such work and led to the painting *La Belle Jardinière* eventually destroyed by the Nazis as an insult to German womanhood. Composed of photos of an anatomical dummy with paper lobes, two birds, a fan, a hat brim, and so on, it was re-photographed to integrate its separate elements and submitted to the third Bauhaus portfolio from which Moholy-Nagy excluded it, saying a photograph was not an 'original' print.

Converted, and in the conversion abandoning his romantic aesthetic baggage, Moholy worked very radically in photography himself, arriving at photograms independently of Man Ray and making 'fotoplastiken' (236) not unlike Ernst's photo-graphics. Photographic experiments, he wrote, helped convince him 'that even the complete mechanisation of techniques may not constitute a menace to its essential creativeness'; he suggested the collector's naive desire for the unique was hardly justifiable and hampered the cultural potential of mass consumption.

A consistent explorer of photographic imagery and among the first artists to edition a photograph in the 1960s, Richard Hamilton wrote of incorporating such an alluring medium into the philosophic contradictions of art and enlarged an image of people on a beach **(238)** to the point where humans became abstract clumps of silver halides and little Jimmy an Arp concretion. Hand and screenprinted additions further questioned photographic 'truth'.

Hamilton's whole-hearted acceptance is by no means general, even now. Jim Dine (who understandably once said he would prefer to be termed hairy, alive, purple and sexy rather than brittle, underrated, Etruscan and dead) collaborated with a photographer in 1969, radically placing his hirsute suggestive etchings alongside exquisite sympathetically matched photographs by Lee Friedlander **(239)**.

Later, writing off the deliciously witty photo-collage *Toolbox* series which he made with Prater in 1966 as 'mearly (sic) a silkscreen reproduction'* Dine avowed printmaking was for him traditional . . . 'deeper, more profound and *handmade*'. But where does that leave Friedlander?

235 **Max Ernst** (1891-1976)
Santa Conversazione 1921
Photographic
25.7 x 17cm

238 **Richard Hamilton**
People 1968
Photograph with screenprinting, collage and gouache
38.5 x 58.5cm

239 **Jim Dine** (b.1935)
with **Lee Friedlander** (b.1934)
Fire alarm from
'Photographs and Etchings' 1969
Etching and photos
45.7 x 76.2cm

* Letter from artist to Tate Gallery Print Department, 5 May 1976

Print equals idea

Over the past decade, print — both typographic and photo-graphic — has become a central means of communication for artists no longer interested in the finite products of painting or sculpture but in art as idea or process and the artist as an enquirer into the nature of art from within art.

Since words, maps and photographs about ephemeral, non-studio events were substituted for the precious studio object, it looked at first as if Conceptual Art (an umbrella term covering a kaleidoscopic range of work dating from the mid-1960s and more interested in the idea than its realisation) would be free of commodity status and market orientation, as would other artistic manifestations such as body art and happenings.

What happened was that words, maps and photos, even Xeroxed sheets, were in time rendered precious. The potentially infinitely reproducible possession-resistant photograph, which Walter Benjamin in his famous 1936 essay* differentiated from painting as without 'aura', was, it appeared, capable of being made artificially unique and priced at several thousand pounds. As Lucy Lippard wrote in 1972: 'Clearly whatever minor revolutions in communication have been achieved by the process of dematerialising the object (easily mailed work, catalogue and magazine pieces, art that can be shown inexpensively and unobtrusively in infinite locations at one time) art and artist in a capitalist society remain luxuries.'

Nor was art so easily dematerialised. A sheet of words or a photograph were as 'material' as a ton of bronze; moreover, in need of as much precision and care in the making.

For some artists, Richard Long and Hamish Fulton, for example, the photograph acts as a coordinate of transient work by providing poetically captioned panoramas or other evocations of their activities in distant landscapes. Others, such as Christo, use it to make both prognostic and memorial prints of vast schemes, as imagined and realised, which help to fund the obsession for wrapping monuments and art galleries, or even miles of the Australian coastline **(252)**.

For some artists, the photograph *is* the work of art. Jan Dibbets relies on its monocular vision for his perspectival corrections, the Bechers record industrial sculptures from every direction, discovering, with Phillippa Ecobichon, the photograph's sequential possibilities, particularly over a period of time **(242)**. Hilliard has explored the nature of photography with the camera. Initially a sculptor, he became aware that more people saw art as relayed by photographs in magazines than viewed it in actuality; the next step, therefore, was to elevate the medium from secondary to primary information source **(240)**. (illustrated on page 15)

242 **Phillippa Ecobichon** (b.1949)
Star Field - Drought and rain 1976/77
Photographs
45.7 x 76.2cm

252 **Javacheff Christo** (b.1935)
Wrapped monument to Leonardo 1970
Documentary lithograph
and photo-lithograph
with collage
74.5 x 55.5cm each of two images

112

* 'The Work of Art in the Age of Mechanical Reproduction' translated in *Illuminations*, Fontana 1973

The camera also relays ephemeral occurrences to those who were not there, capturing situations as varied as the performance where Lizzie Cox, in lithographed gown, all but merges with her background **(250)**, or the charismatic Josef Beuys, rolling himself up in a felt rug or explaining painting to a dead hare, later editions evidence of these activities as printed multiples in an Arts Council catalogue (251). Many such works have political overtones: Wolf Vostell rotary-printed wallpaper for students based on an incident of police brutality (254); Bernd Löbach made a postcard of the hoarding on which a blank poster had been pasted, with the caption: 'as yet not printed on in colour for reasons of profiteering' . . . **(253)**.

The normal categorisation of artists' prints as visual art has been considerably confounded by the recent use that has been made of language. Texts may range from Kosuth's hilarious poster assessing the Venice Biennale (255) to Takamatsu, Jiro's *Story* (256) systematically computerising every possible permutation of letters of the alphabet.

This use of language in art is antedated by concrete poetry, which, employing words visually without discursive syntax, forms a bridge between poetry and painting. Examples have appeared rather more frequently in the literary context of the little magazine than in galleries, thus sharing with literature its tradition of comparatively inexpensive reproducibility. Nevertheless, such poems, thought of as objects rather than songs, have been increasingly the result of collaborative enterprises, echoing the way in which typography is realised by designer, then printer, after an author's idea.

Ian Hamilton Finlay, one of the genre's leading exponents, has caused works to be made in stone, neon, even embroidery; typical of his printed work is the poem based on the word acrobat in which optical colour causes the letters to jump about (243), or *Star/Steer*, in which one word approaches the other in silver lettering on a matte grey ground, a perfect metaphor for a mariner's dark passage lightwards (244). In a three-dimensional conceit, Simon Cutts playfully alludes to the shape and aerial nature of a carrier bag by printing on it **(245)** or, by a line of letterpress changing from green to red with the words 'my favourite flowers — are leaves' encapsulates the nature of the curious blushing Poinsettia plant, revealing the answer to the riddle as one turns the folded card (246). Readily available to anyone within striking distance of a typewriter are the tiny poems, based on keyboard symbols, written by Stuart Mills for his typist (247).

Thus, alongside the development of printed art as a luxury item for an elite, which has subsumed into its maw even the potentially illimitable photograph, there is a continuing and growing countermovement. This accessibility and openness notable in both conceptual and concrete works, makes available by the increasing use of everyday channels of communication an ever widening range of both visual and verbal ideas to anybody ready to receive them.

250 **Lizzie Cox** (b.1946)
Photographs of **Spectrum for scribble** 1975
Lithographed clothing and setting
photographed in performance
25.5 x 17.1cm

245 **Simon Cutts** (b.1944)
Aircraft carrier bag 1972
Screenprint on bag
36.5 x 25.5cm

253 **Bernd Löbach**
Löbach indicator shows you: white paper, as yet not printed on in colour for reasons of profiteering 1972
Photograph of poster event
62·5 × 84 cm

LÖBACH - HINWEISER
zeigt Ihnen:

Weißes Papier, das einmal nicht aus Profitinteressen
bunt bedruckt wurde.

aircraft
carrier

bag

aircraft

carrier
bag

PRINT CONSERVATION

The best way to preserve works of art on paper is to hide them in dark acid-free boxes in an air-conditioned environment. For all light damages paper, bleaching or darkening it, or fading the artists' marks and thereby changing the relationship of figure to ground. Watercolours are especially vulnerable.

A curator wanting to balance preservation for posterity with availability on exhibition exists in a state of eternal compromise and has to exercise common sense since it's not much good preserving something which is never seen. Private owners, without an eye to profitable resale or prospective heirs, may consider they can ignore the museum's long-term view. Nevertheless most might agree that beautiful things are worth caring for, so a few don'ts:

1 Don't hang a work on paper in bright daylight, but in the recessed areas of a room.

2 Don't hang it in a place where temperature is constantly changing (i.e. above a radiator or any kind of ducting, or on a damp outside wall). Paper prefers a temperature of 65 deg.F and a relative humidity (water vapour in the air expressed as a percentage) of 30-70%.

3 Don't let your framer make you a mount of wood-pulp board (which describes the vast majority of cardboards). Make him employ the special conservation board used by museums. To be technical, the pH factor of such a card should be 7, or neutral. Few framers know about these matters, for few customers are willing to pay the extra price, but economies are shortsighted. For ultimately acidic boards (look for the tell-tale orange bevel on old mounts) stain paper, and even worse cause its molecular structure to break down. The acid migrates from sheet to sheet through time, and, like most chemical reactions, is speeded up by heat and damp.

4 Don't use untried glues on prints. Never glue them down. Paper needs to breathe, expanding and contracting with ambient conditions. Hinges of long-fibred Japanese papers and water-soluble glues (old-fashioned library pastes or Polycell wallpaper type) are the best way to secure the sheet to the mount. Abhor cellotape, cow gum, other synthetics and dry or heat mounting. **It's a golden rule to take no action which is irreversible.**

5 Don't use those inexpensive sandwich frames with no edging which allow abrasive dust in. Avoid contact between the image and its glazing. Old-fashioned window mounts get round the problem nicely. For modern prints, the aesthetics of which tend to be anti-mount, an acrylic box, or a frame into which a fillet has been introduced to provide an airspace, are the most desirable solutions. VA perspex (alas, as difficult to get as conservation board) filters out some of the damaging ultraviolet light rays and won't splinter if dropped, so it is worth agitating for. Also perspex reflects changes in temperature less dramatically than glass. However, it should never be used if charcoal or pastel occur in the work, because plastics have an electrostatic charge.

6 Don't let a wooden backboard to the frame come into contact with the print. Acids can migrate from this too. However, they cannot migrate through a plastic sheeting called Melinex made by ICI. Most soft plastics are dangerous to paper if in contact with it for a long time, but this one is inert and conservation approved.

SECTION OF FRAMING WITHOUT WINDOW MOUNT

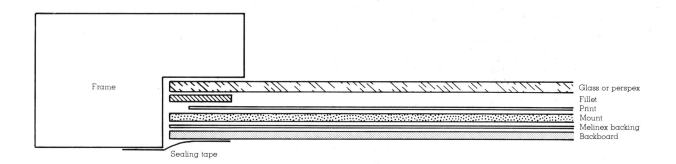

Frame

Glass or perspex
Fillet
Print
Mount
Melinex backing
Backboard

Sealing tape

Conservation board

Japanese paper

Print

SECURING PRINT WITH FOLDED HINGE **PENDANT HINGE FOR HEAVY PRINTS**

GLOSSARY OF TERMS

Aquatint
An intaglio process producing a range of tonal values. Acid is used to etch through a finely grained resist of resin dust fused to the plate by heat. The minute particles of resin leave interstices as a crazed area of bare metal open to the bite of the acid when the plate is immersed in the *etching* bath. Parts of the plate which are to print white remain unbitten, being 'stopped out' (i.e. protected) with varnish from the outset. The darker the print required, the longer the plate remains in the acid and the deeper the incision bitten; the tones can thus be selectively graduated. The resin particles are cleaned off the plate before printing.

Autographic
The artist prepares the printing surface personally — which also implies that the image is 'original.'

Baren
A disc with replaceable bamboo sheath that the Japanese use for hand-rubbing their relief prints (rather than printing in a press).

Bite
The action of acid on the metal is called the bite. Open bite is when the metal is eroded without first applying a resin dust as one does for an *aquatint*.

Burin
A tool used for *engraving* metal or end-grain wood blocks usually having a steel shaft sharpened to a lozenge section and a half-round wooden handle. Also called a graver.

Burr
The furrow of metal thrown up on one or both sides of a direct cut in metal with the *drypoint* tool or the *mezzotint* rocker.

Cliché verre
A technique using photographic paper and a negative hand-made by needling through a light-resistant coating on glass. Recently up-dated in America where other than glass negatives are also employed, producing prints both in black and white and in colour.

Collage
The introduction of other materials into painting and drawing begun in 1912 when Picasso pasted printed oilcloth to a canvas. From the French word coller — to glue.

Collagraph
The printed result of a collage of a variety of materials glued together on a base and printed as a combined relief and intaglio plate. Essentially an American development the name for which was coined in the 1950s.

Collograph
Easy to confuse with *collagraph* above. An adaptation of *collotype* which Henry Moore pioneered with the firm of Ganymed. He drew colour separations on transparent plastic sheets which were transferred to collotype plates by light, thus making original use of a basically reproductive medium.

Collotype
Process in which the image is transferred photographically to a glass or zinc plate coated with light-sensitive gelatine. It can interpret a continuous tone original by means of subtle irregularly reticulated crazing of the gelatine rather than the mechanical dot of *half-tone* and is a medium unmatched for the reproduction of watercolour. It has been largely abandoned because of its fickleness in changing climatic conditions.

Concretion
Name given by Jean Arp to his sculptures because they were real and 'concrete' in the sense of existing in their own right and not as an imitation of something else.

Crayon manner
A printed design built up by minute dots made by a needle or a *roulette* used to penetrate the ground on an etching plate before biting. It was popular in the late 18th century for imitating pastel drawings.

Diazo Lithography
Like *collograph* extensively used by Henry Moore. Developed in the 1960s it employs a sensitised coating on an aluminium plate. The artist draws an image on a transparent sheet (tracing paper or 'Kodatrace' for example) which is developed on the surface of the diazo plate by ultraviolet light. No mechanical screen is used and direct transfer of every nuance in the artist's transparency takes place. Some printers regard it as more sensitive and faithful than the traditionally used lithographic *transfer paper*.

Direct print
One taken directly off the printing surface (as opposed to *offset* in lithography). A disadvantage of direct printing is that the artist must either work in reverse, or accept the fact that his drawing will be turned round in the printing.

Dolly printing
When the forms are far enough apart a dauber (looking like a little rag doll) can be used to apply inks of several different colours to the printing plate in order to print them in one operation rather than from several different plates.

Drypoint
An intaglio print basically linear in character. The image is torn into the surface of a metal plate throwing up the characteristic *burr*. The burr holds ink in such a way that it gives a very rich line. It wears rapidly under pressure from the press however.

Edition
The total number of prints pulled and agreed by the artist for distribution. The number 14/75 written on it means the print in question is fourteenth in an edition totalling 75. Editioning is the printing process, sometimes carried out by the artist, sometimes by a printer.

Engraving
Loosely applied as a generic term for all graphic work, but specifically meaning the direct use, on metal or wood, of a tool called a graver or burin.

Etching
This is a way of incising metal not by the direct use of a tool, but indirectly by exposing selected parts of the plate to acid. Perfected in the early 16th century, it was used first on iron, but copper and zinc are now most common and there are various mordants. A ground, which can be soft or hard, is applied to the plate and the artist then bares the metal by drawing into it with various needles, etc. The plate is then exposed to acid in an etching bath, the time it remains in determining the depth of the incision and therefore its darkness by virtue of the amount of ink it will hold and print. One can systematically cover with varnish those parts of the plate already sufficiently deeply bitten.

Facture
French word referring to obvious signs of making in a work of art, such as brushmarks.

Frottage
A rubbing made by placing a sheet over a relief surface, parts of which stand proud, and taking an impression. Stone and brass rubbings can also be classified as frottage and it is possible to make one on *transfer paper* and put it down on a lithographic plate or stone.

Half-tone
By photographing a continuous tone original through a cross-line screen, it can be broken down into a mass of dots of varying size. When on a printing surface inked with a single colour, the distribution of dots creates the illusion of a full range of tones. Colour half-tone work also involves the preliminary separation of the original into the three primary colours and black by means of filters. If a fine screen is used (175-200 lines to the

inch) the process is almost subliminal; on newsprint the screen used is coarser and the mechanical nature of the process more obvious.

Intaglio
A process involving printing from the recesses below the surface of (traditionally) a metal plate. The plate is heavily inked, filling all the incised channels of the image. The surrounding surfaces are then cleaned by a succession of muslin pads and a final wiping and polishing by the palm of the hand, the ink being stiff enough to remain in the incisions meantime. The plate is then placed on the travelling bed of a rolling press which resembles an old-fashioned domestic mangle. Dampened paper is placed over the plate and cushioned by resilient blankets which force the softened paper into all the ink-carrying incisions during its passage through the press. The print is thus a cast of ink on dampened paper, and the process is distinguished by the plate mark impressed into the paper and the crisp lines standing up from its surface. See also *aquatint*, *drypoint*, *engraving*, *etching*, *mezzotint*, *photogravure*, *soft-ground*, *sugar-lift*.

Jig-saw printing
A way of printing colour, notably practised by the Norwegian artist Edvard Munch, in which the blocks are cut up like a jig-saw each part being separately inked then reassembled for one passage through the printing press.

Line blocks
Letterpress relief block used to reproduce images from black and white originals without intermediate tones. The image is transferred, usually to zinc, by hardening a sensitive emulsion or gelatine by light through a photographic negative. The hardened gelatine is used as an acid resist which protects the wanted parts of the image when the rest of the metal is deep-etched away. One can think of it as a mechanically made *woodcut*

Linocut
Print made from cut lino.

Lift-ground
See **sugar-lift**.

Lithogrcphy
Printing from a level or 'planographic' surface rather than from incisions or protuberances. The fundamental principle involved is the natural antipathy of grease and water. The drawing — on a grained stone or metal alloy plate — is made in a greasy medium called *tusche* which comes in fine or coarse sticks as well as a liquid ink or painterly form. After the image is chemically treated to stop it spreading, the printing surface is dampened so that it will reject ink, while the artist's drawing accepts it. The artist can also work on *transfer paper*. This is specially treated to release the greasy image on it when it is pressed face down on the printing surface.

Lithotint
Fine wash lithograph.

Mezzotint
An intaglio print made from a metal plate by pitting the entire surface with minute indentations which will hold ink. In classic mezzotint, the plate is first roughened in this way with a curved toothed tool called a rocker, so that if printed it would produce an even black field. The artist creates his image by burnishing back the plate to print in graduations of grey or, where it is completely smoothed, white. This black-back-to-white process can be paralleled in lithography by painting or crayoning all over the stone, then subsequently scraping lights.

Moiré
Interference pattern set up between two systematic grids or meshes.

Monotype
Cross between a print and a drawing since there is only one copy. The artist creates an image (perhaps in ink on glass) which is then transferred to a sheet of paper.

Multiple
One can think of records, books, films, even traditional prints all as multiples. But the term really emerged into common usage during the 1960s to describe three-dimensional art objects, different from traditional editioned sculptures in that they employed mass-production processes. Idealists producing them maintained they should be in unlimited editions and inexpensively aimed at democratising art. They disappeared when economic circumstances worsened, but could re-emerge with North Sea oil in the 1980s.

Offset lithography
The image on a lithographic plate is not printed directly but onto an intermediate rubber blanket roller which in turn imparts it to the paper. An incidental effect is that the final image is not reversed, but appears as originally drawn. Although used for the printing of autographic work, there has been intense but rather sterile debate as to whether an offset print can be 'original' particularly since the process is the one used in modern commercial photo-lithography.

Origami
A Japanese art-form in which all kinds of figures are created by folding, but not cutting, sheets of paper.

Original Print
Traditionally defined as 'a print made directly from a master image on wood, stone, metal, etc, which is executed by the artist himself, printed by him or under his supervision and, in recent times, usually signed by him' (OED). However, since the photographic image and other technological factors have infiltrated creative print procedures, 'originality' has become more and more difficult to define adequately, and is probably a term best reserved for traditional prints.

Pantograph
Instrument for exactly copying drawing to any scale.

Papiers découpés
Compositions of pasted papers.

Photogravure
The commercial application of intaglio process. The image is photograhically transferred onto a cellular structure in which are etched hollows of regular area but varying depth (usually 150-175 to the inch) which dictate the amount of ink carried and printed. The hollows are filled, the surface is scraped clean of ink as the printing cylinder revolves, thus automating the process of hand-inking and wiping an intaglio plate.

Photo-lithography
The modern commercial process generally known as *offset* in which the printing plates are prepared by photomechanical means.

Photo-mechanical process
See *line block*, *half-tone*, *photo-lithography*, *photogravure* and *screenprinting*.

Photomontage
Pasted superimposed photographs.

Photo-screenprint
See *screenprinting*.

Pochoir
French term for *stencil*.

Proof
Usually describes an impression pulled to see how the print is progressing. Artist's proofs are a small percentage of the edition retained for personal use (a terminology very much abused in the field of colour reproduction). Printer's proof (in French, the *bon à tirer*, meaning good to pull) is the one finally agreed between artist and printer before editioning proceeds.

Register/Registration

Process of exactly placing the blocks when printing so that successive colours are in the correct relationship. Off-register may mean a fault, or a deliberate feature made of mis-registration.

Relief process

Printing from the upstanding surface which alone is inked. Everyday rubber date stamps work on this principle. See also *woodcuts* and *wood engravings*.

Rétroussage

After inking and wiping an intaglio plate, the plate may be warmed and then tickled with a muslin cloth to pull a little of the ink out of the incisions, in order to enrich the line.

Roulette

Revolving toothed wheel used in engraving.

Screenprinting

Developed in the 20th century mainly as a commercial technique related to stencilling. A fabric (silk, organdie, even metal mesh) is stretched taut on a frame and acts as a carrier for a stencil cut from a thin film of adhered lacquer, or painted directly onto the screen. The screen, like a shallow tray, is lowered onto paper and liquid colour is wiped across the inside with a blade called a squeegee and through the unblocked parts of the mesh onto the sheet. Used as an artistic medium by the Americans in the 1930s the process was called 'serigraphy' (silk drawing) to distinguish it from commerical process. However, in the 1960s artists capitalised on the medium's rich flat deposit of ink as well as using the commercial applications of its photo-technology in which sensitised gelatine films or emulsions can have half-tone dots or other structures photographically transferred to them to produce the stencil.

Serigraph

See *screenprinting*.

Sfumato

Italian term for the gentle blurring of the transition from light to shadow in painting.

Soft-ground

A tacky ground is lifted by setting a sheet of paper over the plate and drawing through it to expose the metal for etching. Imprints of leaves, lace, etc, may also be pressed into a soft-ground and the resulting textures etched. A recent clever adaptation, which surmounts registration problems for colour printing, involves securing the paper which removes the ground to a framework which exactly fits as many intaglio plates as there are to be printed colours. The drawing is then made in coloured crayons. Each time a colour is changed, or a new one introduced, the drawing is moved to the appropriate plate intended to print that shade. Perfect registration ensues. Once there is a basic structure on each plate, other kinds of intaglio mark can be added.

State

A print taken to check progress while the plate, block, etc is still being made.

Stencil

A thin sheet of metal or oiled card through which colour is brushed onto the paper or other surface through holes previously cut in it. Harold Curwen's innovation was the introduction of transparent celluloid as the masking sheet.

Stipple

Dots and flicks with the engraving tool direct on the metal plate.

Sugar-lift

Instead of the usual aquatint process, in which the parts not wanted must be negatively drawn with resist to protect them and the image areas left exposed to be bitten by acid, the plate is resin dusted all over as in normal aquatint, then the artist makes a positive drawing with a special medium. This medium contains sugar ensuring it will never completely dry. When it is as dry as possible, a varnish is laid over the whole plate, which is then immersed in water. The sugary drawing underneath the varnish is attacked along its edges, causing the varnish above it to lift and exposing the plate for aquatinting in the normal way. This enables the artist to capture a spontaneous gesture, or even his own finger prints in the intaglio medium.

Surface tone

A film of ink left on the surface of an intaglio plate to print as a pale grey.

Transfer paper

A special drawing paper from which a lithographic drawing can be transferred to stone or plate by pressure without significant loss of values.

Tusche

Lithographic drawing medium, see *lithography*

Unlimited edition

Actually an impossible concept, because an edition must stop somewhere. However, it means that there is no artificial limitation, and the publisher will print as many as he can sell, or as the printing surface renders possible.

Woodcut

Relief print cut from plank grain with knife, gouge, chisel etc.

Wood Engraving

Relief print made from end grain cut with burins and other fine tools.

ARTISTS AND GROUPS

Abstract Expressionism
Label for the work of a community of artists centred in New York and spanning a decade from the 1940s-1950s. First American school to achieve international fame.

Bauhaus
Famous German design school of the 1920s in which all the arts were to be unified under the umbrella of architecture with no class distinction between artist and craftsman. Famous artists such as Klee and Kandinsky were taken on as teachers there.

Abraham Bosse
Writer of a 17th century treatise on printmaking.

Brücke, Die
A group of German expressionist artists formed in 1905 and initially including Kirchner, Heckel, Schmidt-Rottluff and Bleyl. They were anti-academy.

Constructivism
Manifested itself after the Russian Revolution and demonstrated a conviction that the artist should relate to society using modern methods of production appropriate for new social organisations.

Marcel Duchamp
(1877-1968) Artist who questioned values in the art of his day chiefly by taking everyday objects (a urinal, bottle-rack, bicycle wheel, etc) and putting them into an aesthetic frame of reference where he called them 'ready-mades'. Abhred retinal painting, and suggested the supremacy of idea rather than gesture or manipulation of material.

Théophile Gautier
(1811-1872) French poet, critic and novelist.

Yves Klein
(1928-1962) Artist of the avant-garde who worked on the boundaries of what was acceptable as art, with such works as his famous one colour canvases of 1956.

Minimalism
Recent reductionist tendency in the modern movement characterised by extreme simplicity and deriving much of its force from its intellectual context.

Nabis
A group of artists, including Bonnard and Vuillard, who formed in France in the late 1880s, following a lead given by Gauguin. The name means 'prophet' in Hebrew.

Neo-Impressionism
Late 19th century movement also described as Divisionism and Chromo-luminarism begun by Georges Seurat. Disciples included Signac and Henri-Edmond Cross. They broke down the colours on their canvases according to a scientific theory, applying them in small pure dots and intending them to mix optically in the eye.

Synthetism
A name applied to a tendency apparent in Emile Bernard and Gauguin in which forms are simplified and a synthesis of vision and expression attempted.

Tachism
Tache is french for stain or blot. The word was applied to a European manifestation of semi-abstract painting concurrent with American Abstract Expressionism.

Tamarind
A lithography printmaking workshop begun by June Wayne in Los Angeles in the 1960s, training printers, and inviting artists to work there.

CATALOGUE

1 **Norman Thompson** (b.1951)
A definition of a print 1974
Photo-etching and screenprint
48.5 × 47.5cm image
57.9 × 61.2cm paper
Lent by Cartwright Hall,
Bradford Art Galleries and Museums
illustrated

2 **Marcantonio Raimondi** (1480-1534)
Judgement of Paris (after Raphael) 1510
Engraving
43.8 × 20.1cm
Lent by The British Museum, London
illustrated

3 **Alain Jacquet** (b.1939)
Déjeuner sur l'herbe 1964
Screenprint on two panels
175 × 195cm
Arts Council Collection
illustrated

4 **David Lucas** (1802-1881)
**Reproduction after Constable's
'Spring, East Bergholt Common'** 1829/30
Mezzotint
20.4 × 12.6cm
Lent by The British Museum, London
illustrated

Timothy Cole (1852-1931)
Reproduction after Constable's 'Cornfield'
1899/1900
Wood engraving
15.5 × 13.5cm
Lent by Victoria and Albert Museum, London
illustrated

Timothy Cole
Reproduction after Constable's 'Haywain'
1899/1900
Wood engraving
13 × 19.6cm
Lent by Victoria and Albert Museum, London

Timothy Cole
Reproduction after Constable's 'The Thames'
1899/1900
Wood engraving
12.8 × 19.9cm
Lent by Victoria and Albert Museum, London

5 **After LS Lowry** (1887-1976)
Punch and Judy 1947
Reproductive lithograph
49.5 × 76cm
Arts Council Collection
illustrated

6 **James McNeill Whistler** (1834-1903)
Early morning, Battersea 1878/87
Lithotint
16.4 × 25.9cm
Lent by P and D Colnaghi & Co Ltd, London
illustrated

7 **Leonard Baskin** (b.1922)
Angel of death 1959
Great bird man 1959
Wood engravings and block bearing
both images
157.5 × 78.7cm
157.5 × 81.2cm
Lent by the artist
illustrated

8 **Marcel Broodthaers** (1924-1976)
Museum-Museum 1972
Screenprint
99 × 69cm
Arts Council Collection

9 **Marcel Broodthaers**
Poème-change-exchange-weschel 1973
Screenprint
99 × 69cm
Arts Council Collection
illustrated

10 **Les Levine** (b.1935)
Profit as artwork — Artforum VIII no.6, p.34
1970
Offset lithograph
27 × 26.7cm
Arts Council Collection

11 **Roy Grayson** (b.1936)
This postcard . . . 1970
Lithograph
9 × 14cm each of two
Lent by Pat and Alex Gilmour
illustrated

12 **Eduardo Paolozzi** (b.1924)
Experience (2 variants) from **'As is When'**
1964/5
Screenprints
80 × 55cm each
Lent by Editions Alecto Ltd, London
and Victoria and Albert Museum, London

13 **Eduardo Paolozzi**
For the four from
'For Charles Rennie Mackintosh' 1975
Woodcut
40 × 40cm image
64.9 × 65.4cm paper
Arts Council Collection

14 **Anthony Gross** (b.1905)
Threshing 1954
Oil on canvas
46 × 55cm
Lent by the artist

15 **Anthony Gross**
Threshing 1956
Etching
46 × 53cm
Arts Council Collection
illustrated

16 **Edvard Munch** (1863-1944)
The sick child 1894
Roulette and drypoint
63 × 45cm
Lent by Munch-Museet, Oslo
illustrated

17 **Edvard Munch**
The sick child 1896
Lithograph
53 × 70cm
Lent by Munch-Museet, Oslo
illustrated

18 **John Walker** (b.1939)
No.3 from **'Ten Large Screenprints'** 1974
Screenprint
141 × 102.5cm image 158 × 116cm paper
Arts Council Collection

19 **John Walker**
No.10 from **'Ten Large Screenprints'** 1974
Screenprint
141 × 102.5cm image
158 × 116cm paper
Arts Council Collection
illustrated

20 **John Walker**
Etching, after painting of 1965 1972
Etching
32.5 × 29cm
Lent by the artist, courtesy of
Nigel Greenwood Inc, London

21 **Tom Phillips** (b.1937)
Jusforhus — Humument love song 1970
Screenprint
25.4 × 29cm
Collection of Ian Tyson

22 **Murai, Maçanari** (b.1905)
Three faces 1958
Lithograph
66 × 51cm
Collection of Mr and Mrs James L Hildebrand
illustrated

Murai, Maçanari
Three faces 1963
Woodcut
66 × 51cm
Collection of Mr and Mrs James L Hildebrand
illustrated

23. **Yoshihara, Hideo** (b.1931)
Event II 1966
Lithograph and drypoint
58 × 44cm
Lent by the artist

24 **Noda, Tetsuya** (b.1940)
Diary: September 1st 1974 1974
Screenprint with son's lithograph
46.5 × 64cm
Collection of Mr and Mrs James L Hildebrand
illustrated

25 **Noda, Tetsuya**
Diary: May 7th 1974 1974
Relief print and electrically scanned
stencil plus blocks
24.5 × 20cm
Lent by the artist

26 **Arakawa, Shusaku** (b.1936)
Test mirror from **'Mirrors of the Mind'** 1975
Lithograph, and screenprint, and embossing
74 × 105cm
Courtesy of Multiples, Inc, New York

27 **Matsumoto, Akira** (b.1936)
Botanical encyclopaedia (Chestnuts) 1972
Screenprint and etching
64.5 × 47.5cm
Lent by Cartwright Hall,
Bradford Art Galleries and Museums

28 **Tom Phillips**
Birth of art 1972/73
Acid bitten zinc stencils, printed relief
26.4 × 58.4cm each of ten sheets
Lent by Andrew Colls
illustrated

29 **Ian Tyson** (b.1933)
A line that may be cut 1968
letterpress rule
30.5 × 50.8cm
Lent by the artist
illustrated

30 **Pierre Soulages** (b.1919)
Etching no.11 1957
Etching and aquatint
55.5 × 50cm
Arts Council Collection

31 **Richard Hamilton** (b.1922)
Self portrait 1951
Hard and soft ground, etching, aquatint,
drypoint, engraving and punch
30 × 19.5cm
Lent by the artist

32 **Richard Hamilton**
Picasso's Meninas 1973
Hard and soft ground, etching, aquatint, drypoint,
engraving, punch, lift ground and stipple
57.5 × 49cm image
75 × 57cm paper
Lent by the artist
illustrated

33 **Joe Tilson** (b.1928)
Che Guevara p.39 1970
Photo etching
91 × 63cm
Lent by Marlborough Graphics Ltd, London
illustrated

34 **Pablo Picasso** (1881-1973)
Paloma and Claude from **'Picasso's
Lithographs' Vol.II** 1950
Lithograph
32.2 × 52cm
Lent by John Piper
illustrated

35 **Alan Marks** (b.1939)
Lithograph (Butter or Margarine) 1972
Lithograph
42.5 × 56cm
Lent by Cartwright Hall,
Bradford Galleries and Museums

36 **Bernard Cohen** (b.1933)
Image from **M9 series** 1967
Screenprint
68.5 × 68.5cm
Arts Council Collection

37 **Roy Lichtenstein** (b.1923)
Fish and sky 1967
Photo, textured plastic and screenprint
28 × 35.5cm
Lent by Cartwright Hall,
Bradford Art Galleries and Museums
illustrated

38 **Kimura, Risaburo** (b.1924)
Manhattan (City 8) 1968
Screenprint on ledger paper
35.5 × 43cm
Collection of Mr and Mrs James L Hildebrand

39 **Joe Tilson**
Alchera: Water 1971
Screenprint
97.5 × 67.5cm
Arts Council Collection

40 **Robert Rauschenberg** (b.1925)
Link from **'Fuses'** 1974
Handmade paper, dye and screenprinted tissue
61 × 50cm
Arts Council Collection
illustrated

41 **Robert Ryman** (b.1930)
(e) from **'Portfolio of Seven Aquatints'** 1972
Aquatint
61 × 61cm
Lent by Parasol Press Ltd, New York

42 **John Murphy** (b.1945)
**Tagliare — an incomplete line; 9 impressions
and plate**
1974/75
Engravings
71.3 × 50.8cm each
Lent by the artist

43 **Eric Gill** (1882-1940)
Tennis player 1925
Wood engraving
11.5 × 10.5cm
Lent by Victoria and Albert Museum, London
illustrated

44 **Anonymous**
Two pages from **'Melusina' by Jean d'Arras** 1478
Published by Knoblochtzer
Woodcut block-book, handcoloured
27 × 18.5cm each image
Lent by Victoria and Albert Museum, London
illustrated

45 **Albrecht Dürer** (1471-1528)
The resurrection from **'The Large Passion'** 1510
Woodcut
27.5 × 39.4cm
Lent by The British Museum, London
illustrated

46 **Thomas Bewick** (1753-1828)
Nine proofs from **'The History of British Birds'**
1797-1804
Wood engravings
6.1 × 4.4cm, 8.6 × 4.7cm, 8.6 × 3.3cm,
9.1 × 6.0cm, 8.3 × 5.9cm, 2.9 × 6.4cm,
9.2 × 5.7cm, 7.9 × 4.7cm, 6.9 × 4.4cm
Lent by The British Museum, London
illustrated

47 **Dalziel brothers after Myles Birket Foster**
(1825-1899)
The dipping place and **The stepping stones**
from **'Pictures of English Landscape'** 1863
Wood engravings
17.5 × 13.5cm each
Lent by Victoria and Albert Museum, London

48 **Gustave Doré** (1832-1883)
Block for Boat race from **'London'**
drawn but not cut 1871
Woodblock
20.6 × 25cm
Lent by Victoria and Albert Museum, London
illustrated

Gustave Doré
Holland House from **'London'** 1872
Wood engraving by Dorris
24.5 × 20cm
Lent by Pat and Alex Gilmour
illustrated

Gustave Doré
Illustration from Dante's **'Inferno'**
Wood engraving by Pisan
19·6 × 24·3 cm
Lent by Victoria and Albert Museum, London
illustrated

49 **Elbridge Kingsley** (1842-1918)
White birches c.1889
Wood engraving from photo on block
19.7 × 25.7cm
Lent by Mount Holyoke College Art Museum,
Massachusetts
illustrated

50 **Felix Vallotton** (1865-1925)
L'Emotion 1898
Woodcut and block
18 × 22.5cm image
18 × 22.5 × 21cm block
Lent by Cabinet des estampes
du Musée d'art et d'histoire, Geneva

50 **Felix Vallotton**
Gust of wind 1894
Woodcut
17.4 × 22.2cm image
49.4 × 32.4cm paper
Lent by Cabinet des estampes
du Musée d'art et d'histoire, Geneva
illustrated

51 **Paul Gauguin** (1848-1903)
Manoa tupapau (Elle pense au revenant) 1894/5
Woodcut
20.5 × 35.5cm
Lent by The Home House Trustees,
Courtauld Institute of Art, London

51 **Paul Gauguin**
Auti Te Pape (Les femmes à la rivière) 1894/5
Woodcut
20.5 × 35.5cm
Lent by The Home House Trustees,
Courtauld Institute of Art, London
illustrated

52 **Edvard Munch**
The kiss 1898
Woodcut
42 × 47cm
Lent by Munch-Museet, Oslo

53 **Henri Matisse** (1896-1954)
Grand nu 1906
Woodcut and block
20.9 × 38.1cm image
49.5 × 40cm block
Block lent by Victoria and Albert Museum,
London..Print: Arts Council Collection

54 **Erich Heckel** (b.1883)
Männer Bildnis 1919
Woodcut
45.5 × 32.5cm
Arts Council Collection

55 **Karl Schmidt-Rottluff** (b.1884)
Mädchen aus Kowno 1918
Woodcut
50 × 38.7cm
Arts Council Collection
illustrated

56 **Otto Mueller** (1874-1930)
Mädchen zwischen Blattpflanzen 1912
Woodcut
28 × 37.5cm
Arts Council Collection
illustrated

57 **Anonymous**
Christ on the Mount of Olives c.1470
Photo of manière criblée print
26 × 19.7cm
Courtesy of John Rylands Library,
University of Manchester
illustrated (detail)

Eric Ravilious (1903-1941)
Cockerel and **Chanticleer** from
'Golden Cockerel Press' 1930
Wood engravings
16.5 × 18cm
10.7 × 17.7cm
Lent by Victoria and Albert Museum, London
and the Arts Council Collection

Eric Ravilious
Owl and **Man climbing tree** from
'Natural History of Selborne' 1937
Wood engravings
7.2 × 10.2cm
7 × 10.2cm
Lent by Victoria and Albert Museum, London
illustrated

58 **Munakata, Shiko** (1903-1975)
Toki Hito Omou No Sakis 1964
Woodcut and block
30.5 × 24cm
Lent by Munakata, Parije

59 **Wassily Kandinsky** (1866-1944)
Two plates intended for,
but not used in 'Klänge' 1908 and 1913
Woodcuts
16.4 × 15.2cm
10 × 15.5cm
Lent by Victoria and Albert Museum, London

60 **Kasimir Malevich** (1878-1935)
Suprematist cross (cut in 1921, reprinted
in 1973) 1973
Woodcut
31.5 × 25.5cm
Lent by Fischer Fine Art Ltd, London

61 **Takahashi, Rikio** (b.1917)
Kyoto's voice 1964
Woodcut
95 × 66cm
Collection of Mr and Mrs James I. Hildebrand

62 **Claude Flight** (1881-1955)
Speed c.1925
Linocut
21 × 28cm
Lent by Michael Parkin Fine Art Ltd, London

63 **Gertrude Hermes** (b.1901)
Winter: Rooks and rain 1950
Linocut
76.2 × 35.5cm
Lent by Victoria and Albert Museum, London

64 **Michael Rothenstein** (b.1908)
Cockerel turning round 1956
Linocut
38 × 57.5cm
Lent by Victoria and Albert Museum, London

65 **Pablo Picasso**
Pique (noir et beige) 1959
Linocut
62 × 75cm
Lent by Galerie Louise Leiris, Paris

66 **Edward Bawden** (b.1903)
Brighton Pier 1958
Linocut and key block
53.3 × 144.8cm
Print lent by The Fine Art Society, London
Block lent by the artist

67 **Jozef Gielniak** (1932-1972)
Improvisation for Grazynka II 1965
Linocut
16.5 × 21.5cm
Arts Council Collection
illustrated

68 **Michael Rothenstein**
Black orange red 1965
Woodcut and etched lino
91.4 × 149.8cm
Lent by the artist
illustrated

69 **Rembrandt Harmensz van Rijn** (1609-1669)
The Entombment, states I and IV 1654
Etching, drypoint and engraving
16.1 × 20.9cm each
Lent by The British Museum, London
illustrated

70 **Samuel Palmer** (1805-1881)
The early ploughman 1850
Etching
13 × 19.5cm
Lent by Victoria and Albert Museum, London

71 **Sir Francis Seymour Haden** (1818-1910)
The towing path 1864
Etching and drypoint
14 × 21.5cm
Arts Council Collection
illustrated

72 **Jean-Barthold Jongkind** (1819-1891)
Port d'Anvers 1868
Etching
15.5 × 23.5cm
Lent by Victoria and Albert Museum, London
illustrated

73 **Walter Richard Sickert** (1860-1942)
The New Bedford 1915
Etching
48.8 × 15.2cm
Arts Council Collection

74 **Georges Braque** (1882-1963)
Still life I 1911
Etching
34.5 × 21.5cm
Arts Council Collection

75 **Anthony Gross**
La charcutière 1932
Etching and plate
19.2 × 28.5cm
Lent by the artist
illustrated

76 **Henri Matisse**
Illustration to 'Poesies' by Mallarmé 1932
Etching
33 × 24.5cm
Arts Council Collection

77 **Kim Lim** (b.1936)
Untitled 1974
Drypoint
44 × 44cm image
55.9 × 55.9cm paper
Lent by Waddington and
Tooth Gallery Ltd, London

Kim Lim
Untitled 1974
Photoetching
44 × 44cm image
55.9 × 55.9cm paper
Lent by the artist

78 **Hendrik Goltzius** (1558-1617)
Hercules Victor 1617
Engraving
41.8 × 28.5cm
Lent by Victoria and Albert Museum, London
illustrated

79 **Claude Mellan** (1598-1688)
Christ on the Sudarium 1667
Engraving
43.1 × 32cm
Lent by Victoria and Albert Museum, London
illustrated

80 **Emile Laboureur** (1877-1943)
The entomologist 1932
Engraving
34.5 × 39.5cm
Arts Council Collection

81 **Joseph Hecht** (1891-1952)
Ours blanc from 'Croquis d'Animaux' 1929
Engraving
17.1 × 23.4cm
Lent by Dolf Rieser
illustrated

82 **Joseph Hecht, Joan Miro** (b.1893),
**Wassily Kandinsky, Stanley William
Hayter** (b.1901), **Dolf Rieser** (b.1898),
John Buckland-Wright (1897-1954)
Six intaglio prints from 'Fraternity' 1939
Etchings (Miro & Kandinsky)
remainder engravings
11.6 × 7.2cm, 14.8 × 9.2cm, 13 × 8.2cm,
12.8 × 9cm, 11.8 × 8cm, 12.7 × 7.5cm
Lent by Dolf Rieser

83 **William Hogarth** (1697-1764)
The Marriage Contract
plate 1 of 'Marriage à la Mode'
(with J B Scotin) 1745
Etching and engraving
44.8 × 35.5cm
Lent by The British Museum, London
illustrated

William Hogarth (1697-1764)
Ensnared by a Procuress
plate 1 of 'The Harlot's Progress' 1732
Etching and engraving
32 × 39.5cm (detail)
Lent by Andrew Edmunds
illustrated

84 **Giorgio Morandi** (1890-1964)
**Large circular still life with bottle
and three objects** 1946
Etching
25.7 × 32.4cm
Lent by Victoria and Albert Museum, London

85 **Henri-Georges Adam** (1904-1969)
Ecueils 1959
Engraving
38 × 56cm
Arts Council Collection

86 **David Hockney** (b.1937)
Inside the Castle from
'The Boy who left home to learn fear' 1969
Etching and aquatint
26.5 × 17.4cm
Lent by Hester van Royen Gallery Ltd, London

87 **William Tillyer** (b.1938)
The large bird house 1971
Etching
71.1 × 104.1cm
Lent by Bernard Jacobson Ltd, London
illustrated

88 **Sol LeWitt** (b.1928)
Lines in four directions 1971
Etching
38.1 × 38.1cm
Lent by Parasol Press Ltd, New York
illustrated

89 **Ludwig von Siegen** (1609-1676)
Amelia Elizabeth, Landgravine of Hesse 1643
Mezzotint
31.1 × 43cm
Lent by The British Museum, London

90 **Valentine Green** (1739-1813)
Mary Isabella, Duchess of Rutland,
after Reynolds 1780
Mezzotint
38.3 × 62.8cm
Lent by The British Museum, London

91 **John Martin** (1789-1854)
Book X, lines 312, 347: The Bridge over Chaos
from 'Paradise Lost' 1825/7
Mezzotint
19 × 27cm
Lent by Mr and Mrs Simon Wilson
illustrated

92 **Merlyn Evans** (1910-1973)
Pentaptych III 1961
Mezzotint
99 × 49.4cm
Arts Council Collection

93 **Hamaguchi, Yozo** (b.1909)
Coccinelles 1973
Mezzotint
9.5 × 9.5cm
Lent by David Dalzell-Piper

94 **Wolfgang Gäfgen** (b.1936)
Croix 1975
Mezzotint
39.5 × 52cm image 56.5 × 75.5cm paper
Lent by the artist

95 **Chuck Close** (b.1940)
Keith 1972
Hand burnished, photo etched half-tone structure
132.1 × 106.7cm
Lent by Parasol Press Ltd, New York
illustrated

96 **Dorothea Wight** (b.1944)
Window with blind 1975
Mezzotint and etching
15 × 13cm
Lent by the artist
illustrated

97 **Thomas Gainsborough** (1727-1788)
The watering place 1776/7
Soft-ground with aquatint
25.4 × 33cm
Lent by Iain Bain

Thomas Gainsborough
Wooded landscape with herdsman and cows
Mid-1780s
Soft-ground with aquatint
25.4 × 33cm
Lent by Iain Bain
illustrated

98 **Marc Chagall** (b.1887)
Self portrait with grimace 1924/5
Etching, aquatint, drypoint
36 × 26.5cm
Lent by Victoria and Albert Museum, London
illustrated

Pablo Picasso
Portrait of Vollard from 'The Vollard Suite'
1937
Resist and direct acid on aquatint
34 × 24.5cm
Lent by Victoria and Albert Museum, London

99 **Georges Rouault** (1871-1958)
Onward the dead from 'Miserère et Guerre'
Printed 1927, published 1948
Lift-ground, aquatint, etching and
roulette on photogravure
58.5 × 44cm
Lent by Victoria and Albert Museum, London
illustrated

100 **Pablo Picasso**
Le bélier from 'Histoire Naturelle'
by Buffon 1936
Lift-ground, aquatint and etching
36 × 27.9cm
Lent by Victoria and Albert Museum, London

101 **Pablo Picasso**
Illustrations for 'La Célestine'
by Fernando de Rojas 1968
Etching, lift-ground, and aquatint
21 × 17cm paper size
Lent by Aldo and Piero Crommelynck, Paris
illustrated

102 **Emil Schumacher** (b.1912)
Aquatint 8 1964
Lift-ground aquatint
79.1 × 59.3cm
Lent by Victoria and Albert Museum, London

103 **Colin Self** (b.1941)
Figure No. 2 (triptych) 1971
Resist sprayed on aquatint using live model
as masking device
162 × 62cm
Lent by Editions Alecto Ltd, London
illustrated

104 **Norman Ackroyd** (b.1938)
Rainbow and bridge 1972
Burnished aquatint
49.5 × 45.5cm
Lent by Cartwright Hall,
Bradford Art Galleries and Museums

105 **Alan Green** (b.1932)
Three variations (B) 1974
Direct and indirect intaglio
54.5 × 70cm
Lent by Annely Juda Fine Art, London

106 **Eric Gill** (1882-1940)
The lovers 1924
Engraved wood printed relief and intaglio
8.2 × 3.4cm
7.9 × 3.1cm
126 Lent by Victoria and Albert Museum, London

Eric Gill
The bee sting 1924
Engraved wood printed relief and intaglio
13 × 5cm
13 × 5cm
Lent by Victoria and Albert Museum, London

107 **Rolf Nesch** (1893-1973)
Café Vaterland 1926
Etching
19.6 × 24.5cm
Lent by Ragnhild and Eivind Otto Hjelle
illustrated

108 **Rolf Nesch**
Landøen and **Skaugum** from 'Snow' 1933/4
Metal prints and plate
44.5 × 57cm
43 × 57.8cm
Lent by Ragnhild and Eivind Otto Hjelle
illustrated

109 **Rolf Nesch**
Man with horse's head 1971
Metal print and plate
57 × 43.5cm
Lent by Ragnhild and Eivind Otto Hjelle

110 **Sir Stanley William Hayter** (b.1901)
Viol de Lucrèce 1934
Engraving, soft ground
21.5 × 29.5cm
Lent by Victoria and Albert Museum, London
illustrated

111 **Marc-Antoine Louttre** (b.1926)
Arbres en partie de campagne 1970
Engraved mural from wood printed intaglio
19.2 × 29.5cm
Lent by the artist

112 **Hoshi, Joichi** (b.1913)
Constellation 42 1967
Woodblock and print,
printed from the relief and intaglio
77 × 60cm
Print: Collection of
Mr and Mrs James L Hildebrand
Block lent by the artist
illustrated

113 **Pierre Courtin** (b.1921)
Ville de Cuivre 1958
Engraving
36.6 × 22.9cm image
48.3 × 30.5cm paper
Lent by Galerie Berggruen, Paris
illustrated

114 **Marjan Pogaçnik** (b.1920)
Untitled — two variants 1976 (with plate)
Relief etching, printed blind and
with colour
11.5 × 11.5cm
Lent by Pat and Alex Gilmour
illustrated

115 **Birgit Skiöld** (b.1928)
Image from 'Zen Gardens' 1973
Photo-etching with gouged linocut border
printed blind 30 × 59cm
Lent by the artist

116 **Miyashita, Tokio** (b.1930)
Dragonfly 1968
Woodcut and metal print 35 × 46.5cm
Collection of Mr and Mrs James L Hildebrand

117 **Agatha Sorel** (b.1935)
Wise and foolish virgin 1966
Photo half-tone, etching, aquatint,
hammered brass strip and perspex set-square
78.7 × 56.9cm
Lent by the artist

118 **Werner Schreib** (1925-1969)
The angel wondered why 1967
Plastic intaglio 44.5 × 34cm
Lent by Pat and Alex Gilmour

119 **Joan Miro**
Passacaille 1968
Etching and carborundum print
28.5 × 20cm
Collection Galerie Maeght, Paris

120 **James Guitet** (b.1925)
Plates 1 and 2 from 'Reveries de la Matière' 1964
Material print (carton et relief plastique)
43 × 33cm
Lent by the artist

121 **Etienne Hajdu** (b.1907)
L'Oiseau 1973
Estampille
52 × 43cm
Lent by the artist
illustrated

122 **Maki, Haku** (b.1924)
Poem 71-91 (Nothing) 1970
Wood-cut built up with cement etc.
78 × 38.5cm
Collection of Mr and Mrs James L Hildebrand

123 **Tom Wesselman** (b.1931)
Cut-out nude 1966
Screenprint on vacuum-formed plastic
50.7 × 60.5cm
Arts Council Collection
illustrated

124 **Lourdes Castro** (b.1930)
White shadow 1969
Screenprint on layered acrylic
49.8 × 39.8cm
Arts Council Collection

125 **Ivor Abrahams** (b.1935)
For a time, for a season 1971
Screenprint on cut-outs in perspex box
59 × 76cm
Lent by Cartwright Hall,
Bradford Art Galleries and Museums

126 **Leon Piesowocki** (b.1925)
Aries 1970
Folded print with relief colour
68 × 97.5cm
Lent by the artist

127 **Agatha Sorel**
Raft 1970
Multiple — space engraving on
perspex by pantograph
20.3 × 20.3 × 60.9cm
Lent by the artist
illustrated

128 **Dorothea Rockburne** (b.1934)
Untitled from **'The Locus Series'** 1975
Relief etching and white aquatint on
folded sheet
101.6 × 76.2cm
Lent by Parasol Press Ltd, New York

129 **Richard Parkes Bonington** (1801-1828)
Tour du Gros Horloge, Evreux from
'Voyages Pittoresques' 1824
Crayon lithograph
33.5 × 21cm
Lent by Victoria and Albert Museum, London
illustrated

130 **Honoré Daumier** (1809-1897)
Crie donc, matin! guele donc; plate 2 of
'Croquis d'expressions' in Charivari 1938/9
Lithograph
25 × 35.5cm
Lent by Victoria and Albert Museum, London
illustrated

Honoré Daumier
**Tiens ma femme, voila mon portrait en
Daguerrotype** from **'Les Bons Bourgeois'** 1846
Lithograph
24.7 × 22.5cm
Lent by Victoria and Albert Museum, London

131 **Odilon Redon** (1840-1916)
Il tombe dans l'abime; plate XVIII from **'The
Temptation of St. Anthony'** (third series) 1896
Lithograph
27.8 × 21.2cm
Lent by Victoria and Albert Museum, London

132 **Henri Matisse**
Nu couché et coupe de fruits (Arabesque IV) 1926
Lithograph
43.1 × 53.9cm
Lent by Victoria and Albert Museum, London
illustrated

133 **David Hockney**
Celia smoking 1973
Lithograph
98 × 71cm
Lent by Petersburg Press, London

134 **Adolf von Menzel** (1815-1905)
Pursuit from **'Experiments on stone with
brush and scraper'** 1850/51
Brush, crayon and scraper lithograph
17.7 × 23cm
Lent by Victoria and Albert Museum, London
illustrated

135 **Eugene Carrière** (1849-1906)
Marguerite Carrière 1901/2
Brush and scraper lithograph
42.8 × 34.4cm
Lent by Victoria and Albert Museum, London

136 **Pablo Picasso**
The dove 1949
Brush lithograph
56 × 76cm
Lent by Galerie Louise Leiris, Paris
illustrated

137 **James Rosenquist** (b.1933)
Spaghetti 1970
Lithograph
74 × 104.5cm
Arts Council Collection
illustrated

138 **Pablo Picasso**
The bullfight 1946
Cut-out and transferred lithograph
32.5 × 44cm
Lent by Victoria and Albert Museum, London

139 **Ceri Richards** (1903-1971)
And death shall have no dominion 1965
Lithograph
59 × 81.5cm
Lent by Curwen Prints, London

140 **Jean Dubuffet** (b.1901)
Texte de Terre from **'Les Phénomènes'** 1958/9
Lithograph
37 × 47.6cm
Arts Council Collection

141 **Jasper Johns** (b.1930)
Skin with O'Hara poem 1963-5
Lithograph
55.9 × 86.4cm
Lent by the artist
illustrated

142 **Betty Goodwin** (b.1923)
Shirt four 1971
Soft ground etching
79.5 × 60cm
Lent by Cartwright Hall,
Bradford Art Galleries and Museums
illustrated

143 **Bernd Löbach** (b.1941)
Muss die Hose Mitteilung Machen 1967
Material print
102 × 82cm
Lent by the artist
illustrated

144 **Ed Meneeley** (b.1927)
Illustration for **'Tender Buttons'**
by Gertrude Stein 1965
Electrostatic print
35 × 21.5cm each of 8 pages
Lent by the artist

145 **Anonymous Chinese Rubbing**
**Kuan Ti on horseback; from 3rd year
of Hung Che**
Slab dated 1490, rubbing 20c.
115.5 × 55.8cm
Lent by Victoria and Albert Museum, London
illustrated

146 **Max Ernst** (1891-1976)
Illustrations for **'Je sublime'**
by Benjamin Péret 1936
Frottage
1 10.5 × 7.6cm 2 11 × 7.7cm
3 11.5 × 8.8cm 4 10.5 × 7.6cm
Lent by Galèrie Brusberg, Hanover
illustrated

147 **Max Ernst**
Etoile de mer 1950
Lithograph from frottage
42.5 × 26.5cm
Arts Council Collection
illustrated

148 **Ugo da Carpi** (1450-1523)
Saturn, after Parmigianio
Chiaroscuso woodcut
45 × 43cm
Lent by Victoria and Albert Museum, London
illustrated

149 **Randolph Caldecott** (1846-86)
Illustration for
'The Farmer's Boy' 1881
Wood engraving by Edmund Evans
19.5 × 17cm
Lent by Victoria and Albert Museum, London
illustrated

150 **Voitto Vikainen** (b.1912)
Frosty morning 1954
Woodcut
26.5 × 20cm
Lent by Victoria and Albert Museum, London

151 **Joan Miro**
page 11 from **'A Toute Epreuve'**
by Paul Eluard 1958
Woodcut
32 × 50.4cm
Lent by Gerald Cramer, Mies, Switzerland
illustrated

152 **Lynne Moore** (b.1944)
Poole at Cannes 1970
Cardboard print
79 × 56.5cm
Lent by Cartwright Hall,
Bradford Art Galleries and Museums

153 **Michael Rothenstein**
Love machine 1971
Metal waste, photographic
half-tone, woodcut
66 × 71.5cm
Lent by Cartwright Hall,
Bradford Art Galleries and Museums
illustrated

154 **Carol Summers** (b.1925)
Fonte limon 1967
Woodcut
34 cm
Cartwright Hall,
Bradford Art Galleries and Museums
iIllustrated

155 **Mersad Berber** (b.1940)
Flora et le Roi 1970
Woodcut
165 × 60cm
Lent by the artist

156 **Tajima, Hiroyuki** (b.1911)
The six buttons 1971
Built up woodcut
56.5 × 42cm
Collection of Mr and Mrs James L Hildebrand
illustrated

157 **Mizufune, Rokushu** (b.1912)
Shade bone cut 1964, printed 1972
Woodcut
53 × 38.5cm
Collection of Mr and Mrs James L Hildebrand
illustrated

158 **Thomas Shotter Boys** (1803-1874)
Byloke Abbey, Ghent, from
'Picturesque Architecture in Paris, Ghent' 1839
Lithograph
26.5 × 37cm
Lent by Victoria and Albert Museum, London
illustrated

159 **Henri-Edmond Cross** (1856-1910)
Aux Champs Elysées 1898
Lithograph
20.3 × 26cm
Lent by Victoria and Albert Museum, London
illustrated

160 **Utamaro, Kitagawa** (1753-1806)
Act V from **'The Chushingura series' Godamme**
After 1800
Woodcut
38.1 × 25.9cm
Lent by Robert Sawers
illustrated

Hokusai (1760-1849)
Inume Pass from **'The 36 views of Fiji'** 1823-31
Woodcut
24.5 × 36cm
Lent by Victoria and Albert Museum, London
illustrated

Ikkaisai, Yoshitoshi (1839-1892)
The Actor Kawarazaki Gonjuro 1862
Woodcut
35.7 × 24cm
Arts Council Collection
illustrated

Hiroshige, Ando (1797-1858)
Tsuchiyama from **'53 Stations on the Tokaido'**
1834
Woodcut
22.2 × 35.1cm
Arts Council Collection
illustrated

161 **Auguste Lepère** (1849-1918)
La convalescente (Mme Lepère) 1892
Woodcut
40.6 × 28.8cm
Lent by Victoria and Albert Museum, London
illustrated

162 **Pierre Bonnard** (1867-1947)
Title page from
'Quelques Aspects de la Vie de Paris' 1892
Lithograph
53 × 40cm
Arts Council Collection
illustrated

163 **Jules Chéret** (1836-1932)
Folies Bergère — la Loie Fuller 1893
Lithographic poster
122.8 × 86.3cm
Lent by Victoria and Albert Museum, London
Illustrated

164 **Henri de Toulouse Lautrec** (1864-1901)
Confetti 1894
Lithographic poster
57 × 45cm
Lent by Victoria and Albert Museum, London

165 **Henri de Toulouse Lautrec**
Marcelle Lender en buste saluant 1895
Lithograph
33 × 24.5cm
Lent by Victoria and Albert Museum, London
illustrated

166 **Eduard Vuillard** (1868-1940)
A travers les champs from
'Paysages et Interieurs' 1899
Lithograph
25.5 × 34.3cm
Lent by Victoria and Albert Museum, London
illustrated

167 **Raoul Dufy** (1871-1953)
Harbour scene from **'La Mer'** 1925
Lithograph
30 × 50cm
Lent by Victoria and Albert Museum, London
illustrated

168 **Georges Braque**
La théière grise 1947
Lithograph
50 × 66cm
Lent by Victoria and Albert Museum, London

169 **Pablo Picasso**
Jeune fille inspirée par Cranach 1949
Lithograph
65 × 50cm
Arts Council Collection

170 **Joan Miro**
Personnage au soleil rouge 1950
Lithograph
63.3 × 48.3cm
Arts Council Collection

171 **Marc Chagall**
Painter with palette 1952
Lithograph
61 × 48cm
Lent by Victoria and Albert Museum, London
illustrated

172 **Graham Sutherland** (b.1903)
Predatory form 1953
Lithograph
75.5 × 56cm
Arts Council Collection
illustrated

173 **Trevor Bell** (b.1930)
Tidal objects 1958
Lithograph
49.5 × 36.5cm
Arts Council Collection
illustrated

174 **Sam Francis** (b.1923)
Happy death 1960
Lithograph
62.8 × 88.9cm
Arts Council Collection

175 **William Scott** (b.1913)
Barra 1962
Lithograph
50.3 × 59cm
Arts Council Collection

176 **Paul Wunderlich** (b.1927)
En larmes 1972
Lithograph
65·4 × 50·2 cm
Lent by Cartwright Hall,
Bradford Art Galleries and Museums

177 **Paul Nash** (1889-1946)
Landscape with megaliths 1937
Lithograph
49.1 × 74.2cm
Arts Council Collection
illustrated

178 **Pablo Picasso**
Composition 1949
Colour separation for red drawn on plastic
plate and completed lithograph
46.5 × 76cm
Print: Arts Council Collection
Plate lent by the Trustees of
The Tate Gallery, London
illustrated

179 **Hundertwasser** (b.1928)
Good morning city 1969/70
Embossed screenprint
62 × 85cm
Lent by Aberbach Fine Art, London
illustrated

180 **Thomas Rowlandson** (1756-1827)
with **Augustus Pugin** and **J Bluck**
Bartholomew Fair; Plate 8 from
'The Microcosm of London' Vol. 1 1808
Hand coloured etching and aquatint
19·3 × 26·2 cm
Lent by Victoria and Albert Museum, London
illustrated

181 **Georges Rouault**
Christ et les enfants from **'The Passion'**
by **André Suarès** 1935
Aquatint
30.5 × 21.3cm
Arts Council Collection
iIllustrated

182 **Sir Stanley William Hayter**
Cinq personnages 1946
Plate and engraving with soft ground
and offset colour
38 × 60.5cm image
49 × 66cm paper
Lent by Cabinet des estampes du
Musée d'art et d'histoire, Geneva

183 **Sir Stanley William Hayter**
Pelagic Forms 1963
Colour intaglio from one plate
36 × 44cm
Lent by Denis Bowen
illustrated

184 **Jennifer Dickson** (b.1936)
Et Dieu créa la femme from **'Genesis'** 1965/6
Etching on steel
80.6 × 58.4cm
Lent by Victoria and Albert Museum, London

185 **David Hockney**
Serenade from **'The Blue Guitar'** 1976/7
Etching and soft ground
35 × 42.4cm
Lent by Maurice Payne
illustrated

186 **E McKnight Kauffer** (1890-1954)
'Elsie and the child' by Arnold Bennett 1929/30
Gouache stencil on lithographic key
20.7 × 14.5cm
Lent by Pat and Alex Gilmour
illustrated

187 **Henri Matisse**
Les Codomas and **Le Cheval,
l'écuyère et le clown** from **'Jazz'** 1947
Gouache stencil
42 × 65cm each
Arts Council Collection
illustrated

188 **Commercial stencils**
Vase Press Prospectuses (15, 16, 35, 43, 49, 73)
1920s & 1930s
'Vaseoleo' screenprint
38 × 25cm each
Lent by John Vince
one illustrated

Japanese hair stencil
Early 19th century
Stencil
18 × 27.5cm
Lent by Francis Carr
illustrated

189 **Guy Maccoy** (b.1904)
Still life 1932
Serigraph
23.4 × 31.6cm
Lent by Philadelphia Museum of Art:
Harrison Fund

190 **Anthony Velonis** (b.1911)
Auto-motif 1936/7
Serigraph
30.3 × 40cm
Lent by the artist

Anthony Velonis
6.30 p.m. 1938
Serigraph
35.5 × 26.3cm
Lent by the artist
illustrated

191 **Bernard Steffen**
Haying 1946
Serigraph
25.4 × 20.3cm
Lent by the Philadelphia Museum of Art:
Print Club Permanent Collection

192 **Ben Shahn** (1898-1969)
Passion of Sacco and Vanzetti 1958
Screenprint
32.4 × 41.9cm
Lent by Victoria and Albert Museum, London

193 **Francis Carr** (b.1919)
After the storm 1949
Serigraph
24.5 × 32.5cm
Lent by the artist

194 **Francis Carr**
Hungerford Bridge 1951
Serigraph
37 × 45.6cm
Arts Council Collection
illustrated

195 **Alex Colville** (b.1920)
After swimming 1955
Screenprint
63.5 × 38.1cm
Private Collection, London

196 **Denis Bowen** (b.1921)
Untitled 1956
Serigraph
50.8 × 63.5cm
Lent by the artist

197 **William Turnbull** (b.1922)
Headform (black, yellow, green) 1956
Serigraph
77.4 × 57cm
Lent by the artist
illustrated

198 **Alan Davie** (b.1920)
Yes 1956
Serigraph
34.5 × 26.9cm image
44.8 × 38.2cm paper
Lent by Smith College Museum of Art,
Massachusetts,
Gift of John Coplans

199 **Victor Vasarely** (b.1908)
Bi-Vega 1974
Screenprint
114 × 79cm
Lent by Editions Denise René, Paris
illustrated

200 **Ad Reinhardt** (1913-1967)
Untitled from **'Ten works by ten painters'** 1964
Screenprint
30.5 × 30.5cm
Arts Council Collection

201 **Bridget Riley** (b.1931)
Nineteen greys A 1968
Screenprint
76.2 × 76.2cm
Lent by the Rowan Gallery, London
illustrated

202 **Victor Pasmore** (b.1908)
Hear the sound of a magic tune 1974
Screenprint
219.2 × 66.7cm
Lent by Marlborough Graphics Ltd, London

203 **Stuart Davis** (1894-1964)
Untitled from **'Ten works by ten painters'** 1964
Screenprint
28 × 36cm
Arts Council Collection

204 **Josef Albers** (1888-1976)
Gray instrumentation IIa 1974
Screenprint
48.2 × 48.2cm
Printed and published by Tyler Graphics Ltd,
New York, Copyright 1974

205 **Ay-O** (b.1931)
Mr and Mrs Rainbow B (with fig leaves) 1971
Screenprint
71.5 × 50.5cm
Collection of Mr and Mrs James L Hildebrand

206 **Kim Ondaatje** (b.1928)
Furnace from **'The House
on Piccadilly St' series** 1971
Screenprint
91 × 61cm
Lent by Cartwright Hall,
Bradford Art Galleries and Museums

207 **Patrick Caulfield** (b.1936)
Bathroom mirror 1968
Screenprint
77 × 93cm
Lent by Cartwright Hall,
Bradford Art Galleries and Museums
illustrated

208 **William Blake** (1757-1827)
**Titlepage to 'America,
a Prophecy' (Facsimile)** 1793
Relief etching
23.5 × 17cm
Plate lent by Robert N Essick
Impression lent by Jenijoy La Belle

209 **Aubrey Beardsley** (1872-1898)
The woman in the moon (frontispiece) and
Platonic Lament from **'Salome'
by Oscar Wilde** 1894
Line block
17.5 × 12cm each
Lent by Victoria and Albert Museum, London
illustrated

210 **Max Ernst**
**Une Semaine de Bonté, Book III
La Cour du Dragon,
p48 verso** and **p.50** 1934
Line block
27.2 x 21.8cm
Lent by Victoria and Albert Museum, London

211 **John Heartfield** (1891-1968)
The Finest Products of Capitalism from
'33 Fotomontagen' 1932
Photo-litho after montage
50.7 x 36.4cm
The Arts Council of Great Britain
illustrated

Kaiser Adolf (21.8.32)
**reprint 23.11.39 cover illustration
for Picture Post**
Photo-litho
34.3 x 25.6cm
Lent by the British Library, Lending Division,
London

212 **Jackson Pollock** (1912-1956)
Untitled from **Sidney Janis portfolio** 1951
Photo screenprint
42.1 x 56.4cm
Lent by Philadelphia Museum of Art:
Gift of Mrs H Gates Lloyd

213 **Richard Hamilton** (b.1922)
My Marilyn 1965/6
Screenprint
52 x 63cm (detail)
Arts Council Collection
illustrated

214 **Eduardo Paolozzi**
Selection from **'Moonstrips and
Empire News'** 1967
Screenprints
37.7 x 25.2cm each
Arts Council Collection
illustrated

215 **RB Kitaj** (b.1932)
**The cultural value of fear, distrust and
hypochondria** from **'Mahler becomes politics,
Beisbol'** 1966
Screenprint
42 x 68.5cm
Arts Council Collection
illustrated

216 **Andy Warhol** (b.1930)
Marilyn from **'Ten Marilyns'** 1967
Screenprint
91.5 x 91.5cm
Lent by Cartwright Hall,
Bradford Art Galleries and Museums
illustrated

217 **Ian Colverson** (b.1940)
Portrait 1970
Photo screenprint and computer printout
55.5 × 81.5cm
Arts Council Collection

218 **Joe Tilson**
Ho Chi Minh 1970
Screenprint with wood and collage additions
101.6 × 68.5cm
Arts Council Collection
illustrated

219 **Gerd Winner** (b. 1936)
Bankside 1973
Screenprint on canvas
189.5 × 234.5cm
Lent by Rose and Chris Prater
illustrated

220 **Richard Estes** (b.1936)
Untitled 1973/4
Screenprint
80 x 120cm
Lent by Parasol Press Ltd, New York
illustrated

221 **John Vince** (b.1930); with **John Furnival** (b.1933)
Voir au verso - Kitsch series 1975
Screenprint
77.5 x 58cm
Lent by the artists

222 **Jean François Millet** (1814-1875)
La précaution maternelle 1862
Cliché verre
28 x 22.5cm
Lent by Victoria and Albert Museum, London
illustrated

223 **Jim Nawara** (b.1945)
Horseshoe mound 1974
Cliché verre
35.5 x 45.7cm
Lent by Cartwright Hall,
Bradford Art Galleries and Museums
illustrated

224 **Henry Moore** (b.1898)
Figures in settings 1949
Collograph
60.9 x 44cm
Lent by The Henry Moore Foundation

225 **Ken Danby** (b. 1940)
Early autumn 1971
Screenprint
39.5 x 55.5cm
Lent by Cartwright Hall,
Bradford Art Galleries and Museums
illustrated

226 **Pablo Picasso**
Italian woman (after Victor Orsel) 1953/55
Existing photo-litho reworked with
brush and white line
65 x 50cm
Lent by Galerie Louise Leiris, Paris
illustrated

227 **John Piper**
Llangloffan, Pembroke: Baptist Chapel from
'A Retrospect of Churches' 1964
Litho and photo-litho with plate
59.4 x 81.9cm
Print lent by the artist
Plate lent by Curwen Prints, Ltd, London
illustrated

228 **Richard Hamilton**
The critic laughs 1968
Laminated colour offset litho
with screenprint and enamel
34 x 26cm
Arts Council Collection

229 **Allen Jones** (b.1937)
Life class 1968
Litho and photo-litho
83 x 56cm
Lent by Editions Alecto Ltd, London
print illustrated

230 **Robert Rauschenberg**
Hybrid 1969
Lithograph
138.2 x 91.4cm
Lent by Cartwright Hall,
Bradford Art Galleries and Museums
illustrated

231 **John Piper**
Chapel of St George, Kemptown from
'Brighton Aquatints' 1939
Process engraving with etching
and aquatint
19 x 27cm
Lent by the artist
illustrated

232 **Liliana Porter** (b.1941)
Untitled 1973
Photo etching with pencil
66 x 63.5cm
Lent by the artist

233 **Gerhard Richter** (b.1932)
Landschaft 2 1972
Aquatint and heliogravure
50 x 40cm
Lent by Edition der Galerie
Heiner Friedrich, Munich

234 **Roman Opalka** (b.1931)
Adam and Eve 1963
Photo etching printed in relief
58.5 x 48.5cm
Lent by Cartwright Hall,
Bradford Art Galleries and Museums
illustrated

235 **Max Ernst** (1891-1976)
Santa Conversazione 1921
Photographic
25.7 x 17cm
Lent by DuMont Schauberg, Cologne
illustrated

236 **Laszlo Moholy-Nagy** (1895-1946)
The shooting gallery (rephotographed from
1925 original in 1973)
Fotoplastiken (montage)
28 x 37cm
Lent by Edition der Galerie
Heiner Friedrich, Munich

237 **Barry Flanagan** (b.1941)
Grass II 1967/8
Photograph
53.5 x 82cm
Arts Council Collection

238 **Richard Hamilton**
People 1968
Photograph with screenprinting,
collage and gouache
38.5 x 58.5cm
Arts Council Collection
illustrated

239 **Jim Dine** (b.1935) with **Lee Friedlander** (b.1934)
Fire alarm from 'Photographs and Etchings' 1969
Etching and photos
45.7 x 76.2cm
Lent by Petersburg Press, London
illustrated

240 **Jim Hilliard** (b.1945)
765 paper balls 1970
Photograph
122 x 122cm
Arts Council Collection
illustrated

241 **Bernd and Hilla Becher** (b.1931, 1934)
Coal tipple, Goodspring Pa. — Four Views 1975
Photographs
41 x 49.5cm
Courtesy of Multiples Inc, New York

242 **Phillippa Ecobichon** (b.1949)
Star Field - Drought and rain 1976/77
Photographs
45.7 x 76.2cm
Lent by the artist
illustrated

243 **Ian Hamilton-Finlay** (b.1924)
Acrobats (with Ann Stevenson) 1966
Screenprint
39 x 27.5cm
Arts Council Collection

244 **Ian Hamilton-Finlay**
Steer/star 1966
Screenprint
57 x 44cm
Arts Council Collection

245 **Simon Cutts** (b.1944)
Aircraft carrier bag 1972
Screenprint on bag
36.5 x 25.5cm
Arts Council Collection
illustrated

246 **Simon Cutts**
Poinsettia 1972
Letterpress
11.3 x 15cm
Lent by the artist and the
Arts Council Collection

247 **Stuart Mills** (b.1940)
Poems for my typist 1970
Typewriter
20.8 x 29.6cm each of 7 pages
with the artists permission

248 **Dick Higgins** (b.1938)
This is not an artwork by me 1969
Iron-on screenprint label
25 x 19.5cm
Arts Council Collection

249 **Gabor Attalai** (b.1934)
Process of Baldly (sic) 1974
Hand coloured offset photo-lithographs and hair
33.7 x 32.5cm each of 5 sheets
Lent by Cartwright Hall,
Bradford Art Galleries and Museum

250 **Lizzie Cox** (b.1946)
photographs of **Spectrum for scribble** 1975
Lithographed clothing and setting
photographed in performance
25.5 x 17.1cm
Lent by the artist
illustrated

251 **Josef Beuys** (b.1921)
The chief and **How to explain paintings to
a dead hare** 1964/5 and 1970
Letterpress prints
12.7 x 18 and 18.5 x 11.5cm
Arts Council Collection

252 **Javacheff Christo** (b.1935)
Wrapped monument to Leonardo 1970
Documentary lithograph and photo-lithograph
with collage
74.5 x 55.5cm each of two images
Lent by Cartwright Hall,
Bradford Art Galleries and Museums
illustrated

253 **Bernd Löbach**
**Löbach indicator shows you: white paper,
as yet not printed on in colour for reasons
of profiteering** 1972
Photograph of poster event
62·5 × 84 cm
Lent by the artist
postcard of same event illustrated

254 **Wolf Vostell** (b.1932)
German student wallpaper 1967
Rotogravure in aniline colour
129·5 × 53 cm
Arts Council Collection

255 **Joseph Kosuth** (b.1925)
International local 1976
Lithographic poster
140 x 98.5cm
Lent by Pat and Alex Gilmour

256 **Takamatsu, Jiro** (b.1936)
The story - p.97 1972
Xerox
27·5 × 21·3 cm
Collection of Mr and Mrs James L Hildebrand

LENDERS TO THE EXHIBITION

Aberbach Fine Art, London **179**
Editions Alecto, London 12, **103, 229**
Iain Bain **97**
Leonard Baskin **7**
Edward Bawden 66
Mersad Berber 155
Galerie Berggruen, Paris 113
Denis Bowen **183,** 196
Bradford, Cartwright Hall, Art Galleries &
 Museums **1,** 27, 35, **37,** 104, 125, **142,** 152,
 153, 154, 176, 206, **207, 216, 223, 225, 230,
 234,** 249, **252**
Galerie Brusberg, Hanover **146**
Francis Carr **188,** 193
Andrew Colls **28**
P & D Colnaghi & Co Ltd, London **6**
Lizzie Cox **250**
Gerald Cramer, Mies, Switzerland 151
Aldo & Piero Crommelynck, Paris **101**
Curwen Prints Ltd, London 139, **227**
Simon Cutts 246
David Dalzell-Piper 93
Editions Denise René, Paris **199**
DuMont Schauberg, Cologne **235**
Phillippa Ecobichon **242**
Andrew Edmunds **83**
Robert N Essick 208
The Fine Art Society, London 66
Fischer Fine Art Ltd, London 60
John Furnival 221
Wolfgang Gäfgen 94
Pat and Alex Gilmour **11, 48, 114,** 118, **186, 255**
Geneva, Cabinet des estampes du Museé
 d'art et d'histoire **50,** 182
Anthony Gross **14, 75**
James Guitet 120
Etienne Hajdu **121**
Richard Hamilton 31, **32**
Galerie Heiner Friedrich, Munich 233, 236
Mr and Mrs James L Hildebrand **22, 24,** 38, 61,
 112, 116, 122, **156, 157,** 205, 256
Ragnhild and Eivind Otto Hjelle, **107, 108,** 109
Hoshi, Joichi **112**
Bernard Jacobson Ltd, London **87**
Jasper Johns **141**
Annely Juda Fine Art, London 105
Jenijoy La Belle 208
Galerie Louise Leiris, Paris 65, **136, 226**
Kim Lim **77**
Bernd Löbach **143, 253**
London, Arts Council Collection 3, **5,** 8, **9,** 10,
 13, **15,** 18, **19,** 30, 36, 39, **40,** 53, 54, **55, 56,**
 57, **67, 71,** 73, 74, 76, 80, 85, 92, **123,** 124, **137,**
 140, **147, 160, 162,** 169, 170, **172, 173,** 174,
 175, **177, 178, 181, 187, 194,** 200, 203, **213,**
 214, 215, 217, 218, 228, 237, **238, 240,** 243,
 244, **245,** 246, 248, 251, 254
London, Arts Council of Great Britain 211

London, British Library 211
London, British Museum 2, **4,** 45, 46, 69, 83,
 89, 90
London, The Home House Trustees, Courtauld
 Institute of Art 51
London, Tate Gallery 178
London, Victoria & Albert Museum 4, 12, **43,**
 44, 47, **48,** 53, **57,** 59, 63, 64, 70, **72, 78, 79,**
 84, **98, 99,** 100, 102, 106, **110, 129, 130,** 131,
 132, 134, 135, 138, **145, 148, 149,** 150, **158,**
 159, 160, 161, 163, 164, **165, 166, 167,** 168,
 171, 180, 184, 192, **209, 210, 222**
Marc-Antoine Louttre 111
Galerie Maeght, Paris 119
Manchester, John Rylands Library, University
 of Manchester **57**
Marlborough Graphics Ltd, London 33, 202
Ed Meneeley 144
Stuart Mills 247 **(lent the idea)**
Henry Moore Foundation 224
Multiples Inc., New York 26, 241
Munakata, Pariji 58
John Murphy 42
Noda, Tetsuya 25
Northampton, Massachusetts, Smith College
 Museum of Art 198
Oslo, Munch-Museet 16, 17, 52
Parasol Press Ltd, New York 41, **88, 95,** 128, **220**
Michael Parkin Fine Art Ltd, London 62
Maurice Payne **185**
Petersburg Press, London 133, **239**
Philadelphia Museum of Art 189, 191, 212
Leon Piesowocki 126
John Piper **34, 227, 231**
Liliana Porter 232
Rose and Christopher Prater **219**
Dolf Rieser **81,** 82
Michael Rothenstein **68**
Rowan Gallery, London **201**
Robert Sawers **160**
Birgit Skiöld 115
Agatha Sorel 117, **127**
South Hadley, Massachusetts, Mount Holyoke
 College Art Museum **49**
William Turnbull **197**
Tyler Graphics Ltd, Bedford, New York 204
Ian Tyson 21, **29**
Hester van Royen Gallery Ltd, London 86
Anthony Velonis **190**
John Vince **188, 221**
Waddington and Tooth Gallery Ltd, London 77
John Walker 20
Dorothea Wight **96**
Mr and Mrs Simon Wilson **91**
Yoshihara, Hideo 23
Private collection 195

132

INDEX

Photographs courtesy of:
Courtauld Institute of Art
Prudence Cumming Associates Limited
Bevan Davies
Fot, Witalis Wolny
John R Freeman and Company
Etienne Hajdu
Bernard Jacobson Limited
Galerie Louise Leiris
Bernd Löbach
Marlborough Graphics Limited
Munch-Museet
Petersburg Press
Prawa Autorskie Zastrzezone
Nathan Rabin
The Tate Gallery
Universal Limited Art Editions
John Webb